SANTA FE ICONS

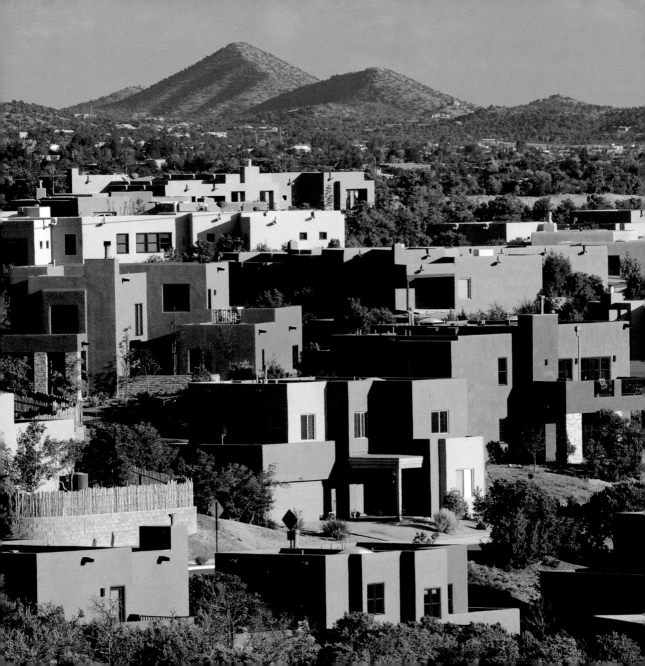

SANTA FE ICONS

50 SYMBOLS OF THE CITY DIFFERENT

Camille Flores

photographs by Gene Peach

gpp®

Guilford, Connecticut

To buy books in quantity for corporate use
or incentives, call **(800) 962-0973**
or e-mail **premiums@GlobePequot.com.**

Thanks go to the following people and organizations for their aid in producing the photos contained in this book: p. 2, Outside In; p. 11, Shalako Indian Store; p. 31, Tomasita's; p. 33, courtesy of The Santa Fe Opera; p. 39, Santa Fe Kiwanis Club; p. 47, The Abobe Man; p. 49, Maria's, Tomasita's, and Santa Fe School of Cooking; p. 51, Ten Thousand Waves; p. 55, Maria's and Tomasita's; p. 75, Maria's; p. 83, Bobcat Bite and Old Las Vegas Highway; p. 93, Santa Fe Chamber Music Festival

Project editor: Gregory Hyman
Text design: Casey Shain

Library of Congress Cataloging-in-Publication Data

Flores, Camille.
 Santa Fe icons : 50 symbols of the city different / Camille Flores ; photographs by Gene Peach.
 p. cm.
 ISBN 978-0-7627-5661-2
 1. Santa Fe (N.M.)—Description and travel. 2. Santa Fe (N.M.)—Pictorial works. 3. Santa Fe (N.M.)—Social life and customs. 4. Historic buildings—New Mexico—Santa Fe. 5. Historic sites—New Mexico—Santa Fe. 6. Santa Fe (N.M.)—Buildings, structures, etc. I. Title.
 F804.S24F55 2010
 978.9'56—dc22
 2009049145

Printed in China

10 9 8 7 6 5 4 3 2 1

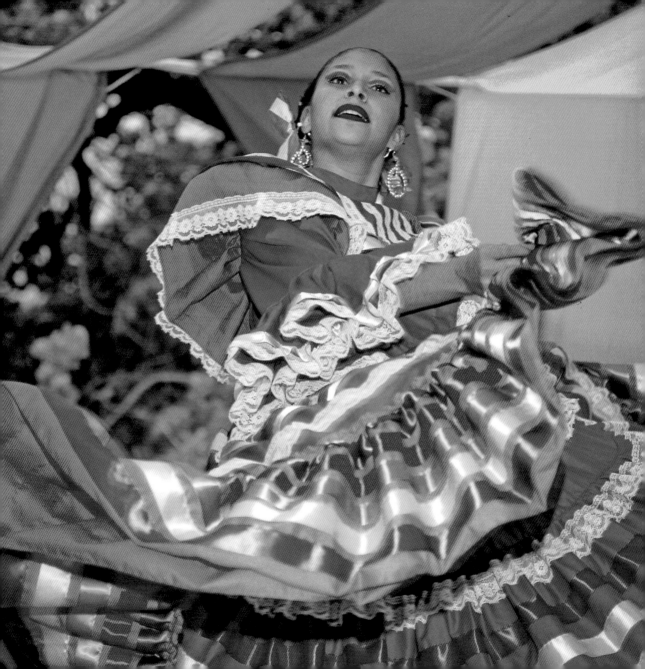

CONTENTS

INTRODUCTION

For many years I would hurry past the windfall fruit from Santa Fe's old apricot trees where it cluttered the sidewalk. It wasn't mine, I thought, so I can't take it; better to let it rot where it lies.

Then I heard the "public fruit" rule, which states that any fruit that falls on public property (such as sidewalks) belongs to everyone. In fact, it would even be okay to reach up and gather apricots (or lesser fruits) from the branches that overhang the fence. My world became a happier, tastier place.

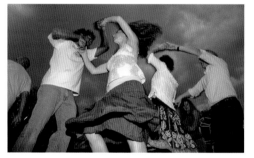

If we take that rule and apply it to cultures, ours or someone else's, our horizons also may expand. A shared harvest of the historic, spiritual, and temporal fruits of our societies enriches all, and wastes nothing. In fact, a little seed from a piece of public fruit may someday produce a magnificent tree far from its parent. One never knows.

That's the spirit with which I approached this book on Santa Fe icons—as a way of sharing the abundance of an absolutely unique high-desert city, home of ancient and new cultures; of small things (city population 70,000; county, 140,000) and large (world-class art and amenities); of tradition and science. By gathering and sampling from among the public images of Santa Fe, we can discover exciting new flavors, or simply savor the already-familiar ones.

The people of Santa Fe live with a sense of unwavering awe. I've never known one who didn't meet our amazing sunsets with a hand to heart and an intake of breath. This is a magical place. Visitors come here to experience something entirely different, even though for many, it's still close to home, still "America." We have much in common, and much to share.

I hope that by sampling these "fruits" of Santa Fe, you will come to know the tree, and that you and I will never hesitate to partake of a cultural feast, no matter where we find it.

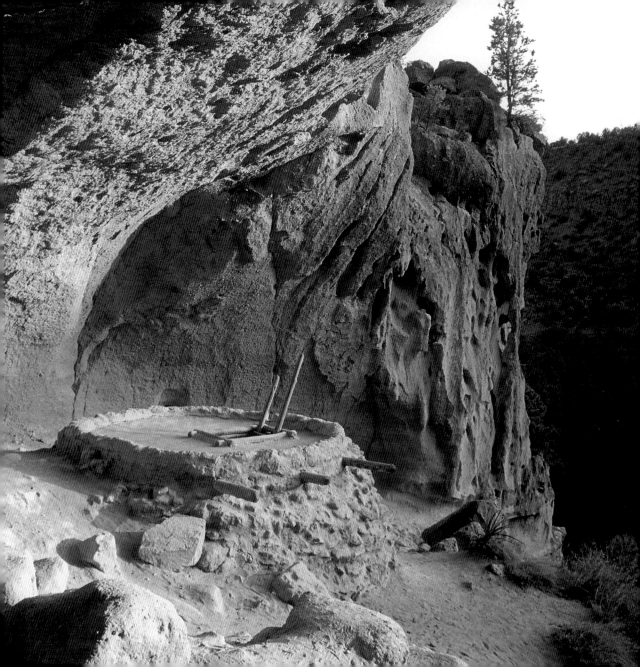

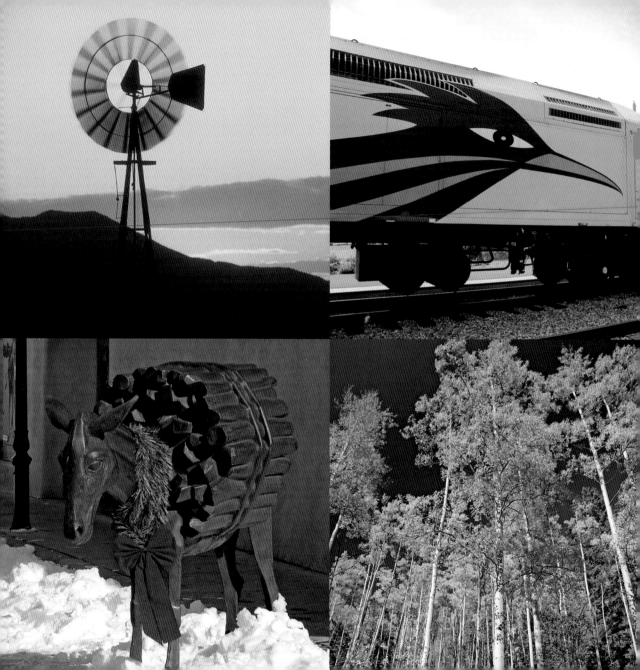

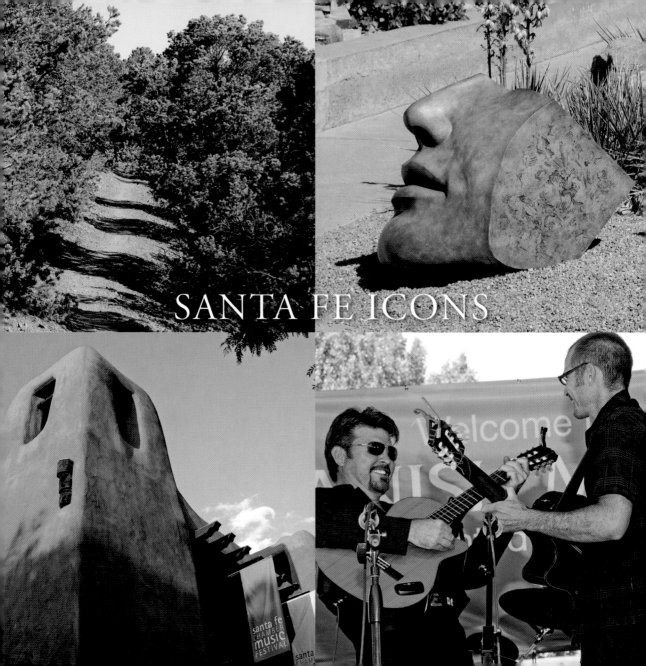

SANTA FE ICONS

THE PLAZA

Artistic renderings of the Santa Fe Plaza often capture remote, reflective images: a near-empty park in gray rain or fresh snowfall; a sun-weathered bench; wind in the treetops. It's as if artists acknowledge the Plaza as a distinct character, worthy of interpretation on its own merit.

Yet this small square in the heart of downtown Santa Fe usually teems with life. Markets, fiestas, parades, protests, and civic events draw large crowds to the Plaza. On a daily basis, it's difficult to find a free bench during the noon hour, as vendors, dog walkers, tour groups, teenagers, buskers, and politicos meet and greet. The Native Americans selling handcrafted art under the portal of the Palace of the Governors are a major tourist attraction.

There are plazas like ours across Latin America. All were built on the same model of Spanish settlement— a government house, military buildings, and a church or chapel framing a four-

Santa Fe Plaza
Palace Avenue
San Francisco Street
Old Santa Fe Trail
Lincoln Avenue

sided park. Since 1610, when Santa Fe officially became a *villa* of the Spanish realm, our Plaza has played many roles—as a military presidio; as the site of a bloody battle in the Pueblo Indian Revolt of 1680; as the hectic terminus of the Santa Fe Trail. After Santa Fe became the capital of a U.S. Territory in 1848, it met the needs of a new government.

But for most of its 400-year history, the Plaza has been the heart of Santa Fe's social life, the place where neighbors, young and old, congregate in the evenings, listening to music from the bandstand, strolling and dancing under the stars. Today, the city sponsors Santa Fe Bandstand, which brings musicians to the Plaza in the summertime. Locals gather to dance and to revel in the lively atmosphere, restoring the centuries-old relationship between people and their park. Could this bond and shared history be the "character" revealed in modern-day portraits of the Plaza?

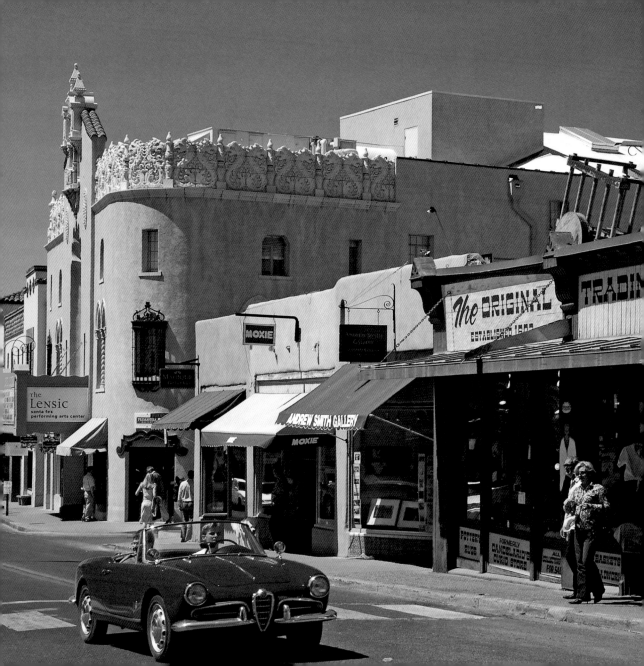

JACKALOPE

Jackalope owner Darby McQuade created a global, folk-art shopping village to merge his interests in travel and world cultures with his need to make a living. The several-acre funky town on busy Cerrillos Road comprises several cavernous "shops" selling everything from roasted green chile to opulent Indonesian furnishings. If you can imagine it, it's probably at Jackalope.

It's the first place locals think of when visitors invariably ask, "Is there a place to buy nice souvenirs that don't cost a fortune?" A major hop from the Plaza, Jackalope's location on busy Cerrillos Road requires a drive, but can be a welcome respite from Plaza-area craziness and prices. Once inside the compound, visitors are encouraged to wander, to meet the artisans working there, and to discover the unexpected, including the resident menagerie of pet doves, prairie dogs, and barn animals.

Though many might love to live

Jackalope
2820 Cerrillos
Road
www.jackalope
.com

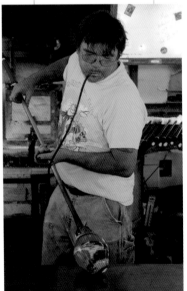

at Jackalope, McQuade actually does, and his daily walks among the shops and greenhouses allow him to connect with the customers who make Jackalope a top tourist attraction in Santa Fe. A jackalope, for those who don't know, is an elusive desert creature, half jackrabbit and half antelope, that's rarely seen despite evidence of its existence. It's an apt name for a store the likes of which most people had only dreamt of, but not seen, before it opened in 1976.

The inexplicable inventory—based on the owner's travel whims, one guesses—changes often, especially when the seasons do. Egypt, Thailand, the African nations, Latin America—all are represented. Inevitably, Jackalope's popularity led to expansion outside of the City Different. There are now two Jackalopes in the Albuquerque area, one in Colorado and another in California. Santa Fe's is the original, though, and can't be matched in scope or character.

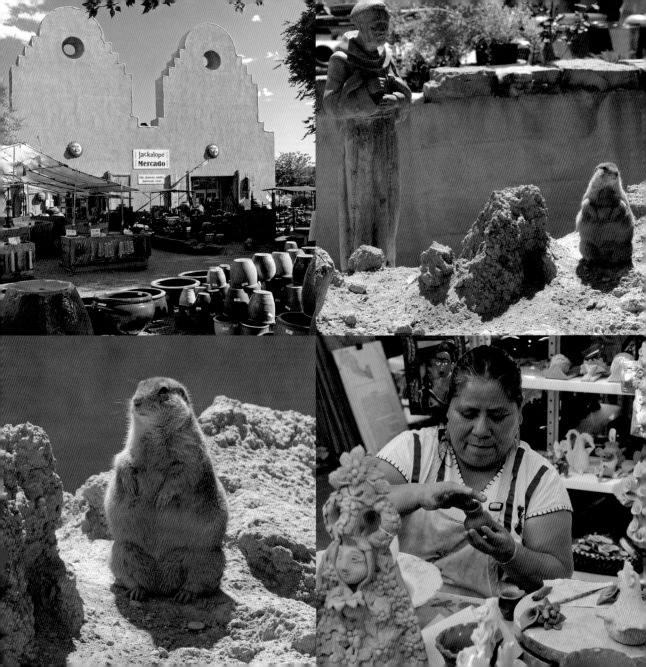

OLD SANTA FE TRAIL

When it opened officially in 1821, the Santa Fe Trail looked to many like the road to riches. U.S. traders had been champing at the bit to capture Mexican markets once that country freed itself from Spain and her protectionist economic policies in the Mexican War of Independence. Conversely, Mexico, then in its infancy, was greatly in need of money, and its businessmen actively sought trade with its northern neighbor.

Santa Fe was in the best position to facilitate the new flow of commerce because of its location at the intersection of the Santa Fe Trail, which began 900 miles to the east in the Missouri frontier, and the Camino Real de Tierra Adentro, the renowned trade route into the interior of Mexico.

The Plaza was the terminus of the Santa Fe Trail, and those who traveled it looked forward to arriving there with great joy—not just because a difficult journey had ended, but because the people of

Journey's End Sculpture 725 Camino Lejo at Old Santa Fe Trail (Museum Hill entrance)

Santa Fe Trail Northeast New Mexico www.santafe trailnm.org

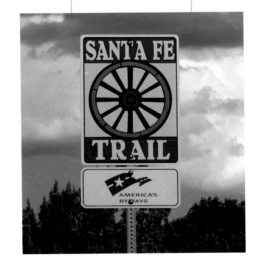

Santa Fe welcomed them so warmly, singing songs and shouting as *los cara-vanos* approached. About a half-mile from the Plaza, the wagons would slow down, and the bullwhackers would crack their whips to sound like fireworks, their contribution to the joyful noise. Then the Plaza would teem with animals and people, goods and wagons, becoming a combination campground and bazaar—a convergence of cultures and ideas that presaged the dawn of a new Santa Fe.

The Santa Fe Trail was not a single road, but several braiding trails that followed old Indian and buffalo routes. The Cimarron Route, which cuts across northeastern New Mexico, is today a designated 200-mile scenic and historic byway, with many landmarks and sites along the way. The swales made by the old wagons are visible from many points along the route, where they're etched permanently into the history of New Mexico.

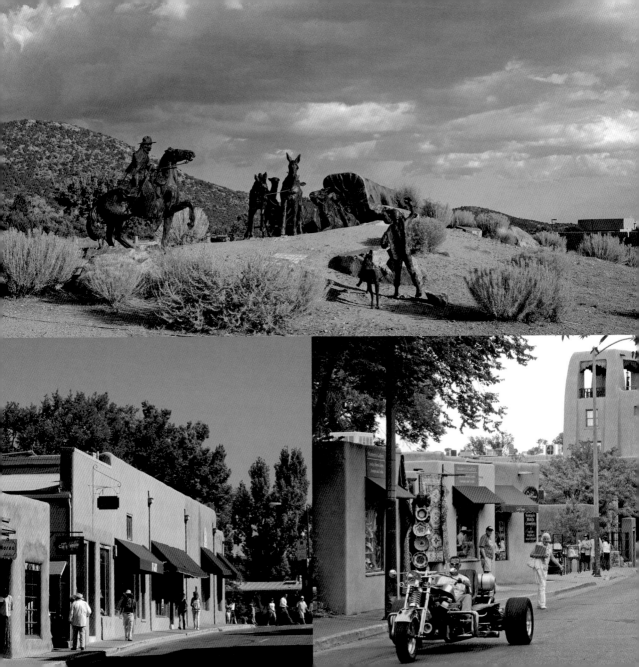

THE ROUNDHOUSE

It wouldn't be fair to describe New Mexico's state capitol, also known as the Roundhouse, as a purely Santa Fe icon. Every detail of the building, dedicated in 1966 and renovated between 1989 and 1991, reflects the history and cultural diversity of the entire state. What the building derives most from its location in Santa Fe, perhaps, is the celebratory integration of regional art in its architecture and design.

The building itself depicts the Zia sun symbol—circular, with extensions representing the four directions. Its brown stucco finish blends with the adjacent adobe buildings along historic Old Santa Fe Trail, which passes directly in front of it. Even the grounds are designed to showcase native shrubs and trees, which defy manicure or symmetry. Many visitors pass this capitol without realizing they've done so.

The capitol has four levels. Visitors enter on the second floor, which contains a gallery for viewing leg-

Tour Information: capitolarts@ nmlegis.gov (505) 986-4589

islative sessions below. The staff is proud to tell you that the entire capitol is open to the public—if not to view the legislature in action, then to enjoy its premier art collection. During the reconstruction of the building, a percentage of the budget was set aside to purchase art from New Mexico artists—sculptors, painters, weavers, furniture makers, and tinsmiths among them. Through this grant and the generosity of patrons, the Roundhouse now boasts a $6 million art collection spread throughout the building, as it would be in a home.

In addition, the governor's own office displays a rotating exhibit of New Mexico art in what's known as the Governor's Gallery. This display is changed about once every three months. Outdoors, the grounds are graced with monumental sculptures that invite leisurely viewing. Guided tours of the capitol and the art are scheduled daily.

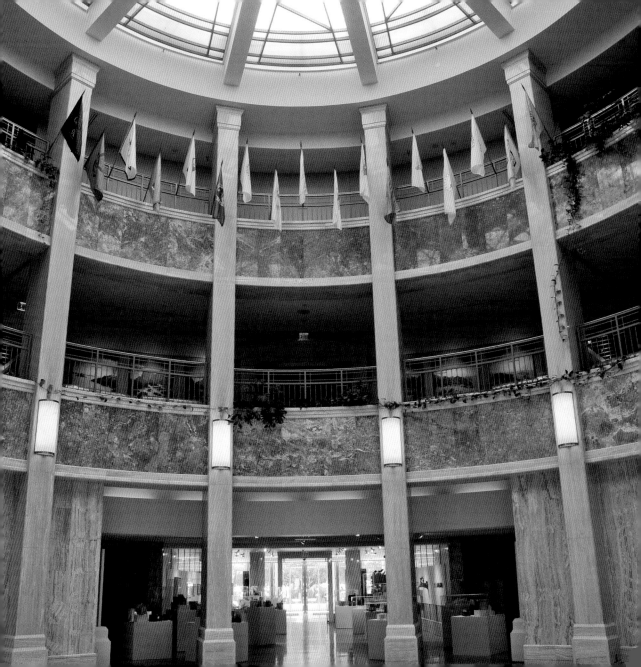

TURQUOISE

Although turquoise is often described as a blue-green stone, the gems appear in shades ranging from deep blue to lime. Stones on the deeper side of blue simply have a higher copper content; green stones have more iron. The exotic dark streaking (called the "matrix") is formed by the intrusion of minerals into the stone under enormous natural pressure.

With its intense color and timeless beauty, turquoise lends itself well to the crafting of ethnic jewelry. That's certainly true in the United States, where it's primarily associated with the Native American culture. Interestingly, it was the Spanish who introduced silverwork to the indigenous people of the Southwest. And it was "American" traders (especially trading post owners) who opened the door to an East Coast market in thrall with all things "Western" in the late 1800s and early 1900s.

Native Americans were mining turquoise in the hills south of Santa Fe for ritual, ornamentation, and trade for centuries before the Europeans arrived.

To view collections:
Packards, on the Plaza
(505) 983-9241

Museum of Indian Arts and Culture
Museum Hill
(505) 476-1250

Incorporating their own symbols and motifs on silver settings was a small step for the Native people, but an important one. They defined American turquoise jewelry, and their work remains the standard.

Some of the most desirable pieces were created before World War I, including what is called "Old Pawn." Trading post owners often allowed local Indians to pawn their jewelry when money was needed, but the intention was not to keep it for resale. Jewelry in the Native culture is intimately linked to the owner, and often accompanied him or her to the grave, so authentic Old Pawn is rare. The rest of the jewelry from this period and through the 1930s is considered antique, and is just as fine a representation of the era.

Many contemporary turquoise artists respect the traditional style while embracing the aesthetic values of their own generation. Current descriptions like "contemporary antiques," "modern artifacts," and "ethno chic" aptly describe their work.

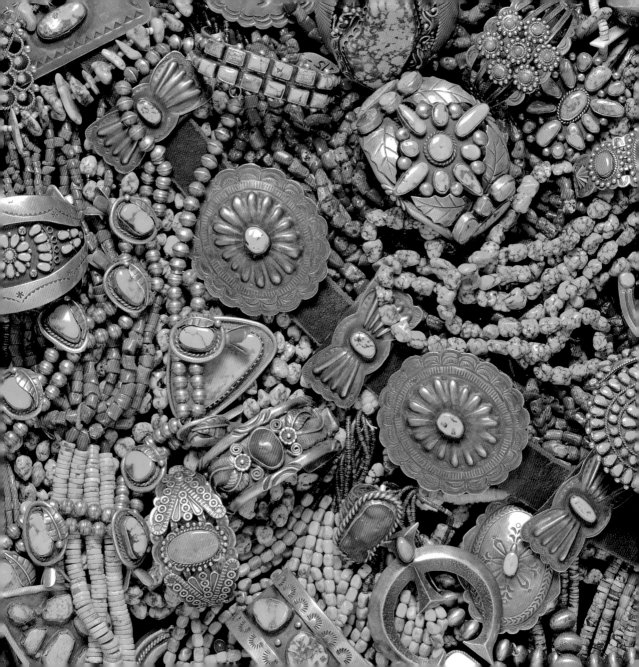

INDIAN MARKET

There are nineteen sovereign Indian Pueblos, and the Navajo and Apache nations, in New Mexico. Given its geographical location, Santa Fe is literally central to the most diverse concentration of Native peoples in North America and the privileged venue for the annual Indian Market.

In late August, the entire city focuses on the Santa Fe Indian Market and related events. Galleries exhibit the work of groundbreaking Indian artists; special events showcase Native music, cinema, and fashion; and museums hold lectures and workshops.

The sponsoring organization, the Southwestern Association for Indian Arts (SWAIA), has worked year-round for nine decades to promote and advocate for Indian arts and artists. Its judges determine who may participate, and the organization sets and enforces strict standards for the work. Its panel of experts selects winners in several categories, including jewelry, pottery, wood carvings, textiles, beadwork, bas-

SWAIA
141 East Palace Avenue
(505) 983-5220
www.swaia.org

IAIA Museum
108 Cathedral Place
(505) 983-8900

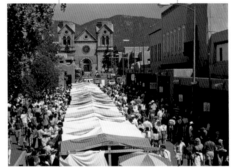

kets, and sculpture. Only winners in the individual categories are eligible to win Best of Show, an honor that can change a life, and, sometimes, the direction of the art itself.

In fact, the evolution of Indian Art, as a reflection of what is occurring in the community that inspires it, is critical to its viability. This has been the dominant philosophy in Santa Fe since the 1960s, when a group of established Native artists—Allan Houser, Fritz Scholder, and Lloyd Kiva New among them—founded the Institute of American Indian Arts as a place where young Native artists from across the country could come together, study, and determine their own definitions of "Indian" art. The resulting shift from market-driven to voice-driven pursuit of art changed the genre forever, along with the worldview of America's Native people. This spirit of self-determination fuels an authenticity that permeates and drives the Santa Fe Indian Market.

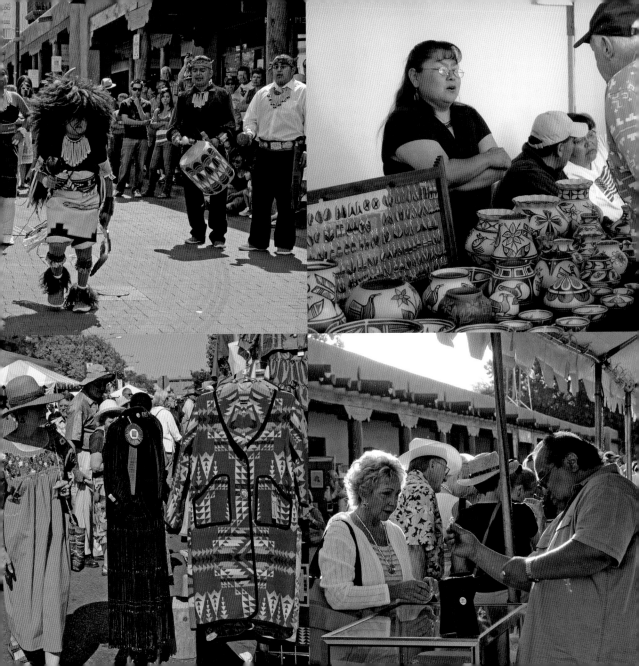

OUR LADY OF GUADALUPE

At the venerable age of 400-plus years, Santa Fe rarely grants icon status to newcomers. An exception is a statue of Our Lady of Guadalupe that arrived in the summer of 2008 amid great fanfare and is already one of the city's most visited monuments. The larger-than-life bronze statue, situated prominently on a knoll overlooking the Santa Fe River on Our Lady of Guadalupe Church property, beckons all who pass to stop and contemplate.

That's exactly as it should be: The lovely chapel adjacent to the statue began as a sanctuary for travelers on the Camino Real, the main route from interior Mexico. Inside, a huge painting of Our Lady of Guadalupe by Spanish Colonial artist José de Alzibar offers another focus for prayerful reflection. Following its completion in Mexico City in the 1780s, the painting was rolled up in sections and draped across the backs of burros for the 1,500-mile trek northward to its new home in Santa Fe.

Our Lady of Guadalupe Church 417 Agua Fria (at Guadalupe Street)

No less colorful was the bronze statue's journey here. Created by Mexico City artist Georgina Farias, it, too, traveled up the Camino Real, and was met by many of the joyous faithful along the way. Despite their good wishes, however, border guards in Juarez, Mexico, deemed the statue "suspect" and "detained" it unceremoniously in a warehouse for further investigation— without notice! Following a frantic search-and-rescue effort, the long-anticipated Guadalupe arrived in Santa Fe, swathed in bubble wrap and riding in the back of a parishioner's truck.

As it approached the church, a welcoming procession arrived from the Cathedral Basilica of St. Francis, holding aloft the city's oldest Marian image, a wooden statue of La Conquistadora, also called Our Lady of Peace, brought to Santa Fe around 1625. In a sublimely Santa Fe moment, the two icons met "face-to-face" (and some say, smile-to-smile), blessing the bond between old and new in the City of Holy Faith.

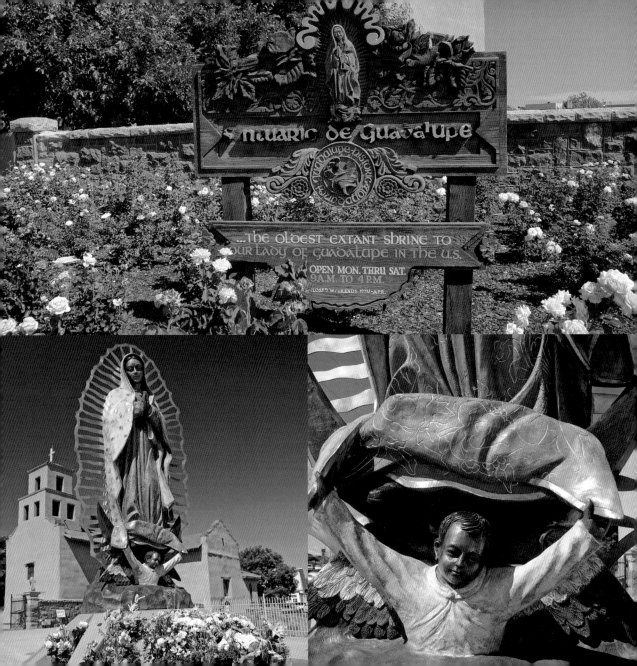

LENSIC PERFORMING ARTS CENTER

Designed by the famous Boller Brothers of Kansas City, the Lensic Theater opened in 1931 as a vaudeville and film house, one of many grand theaters built in the West in towns of stature. As such, it served the community proudly and well for decades—until the pseudo-Moorish, Spanish Renaissance grandeur began to fade and the needs of visiting artists had changed. By the 1990s, Santa Fe faced the inevitable question: raze, or renovate?

Happily, there was a void to fill in Santa Fe, and a few indefatigable citizens ready to assume the task of filling it. For despite its reputation as a world-class arts destination (Santa Fe is a UNESCO-designated creative city), it lacked a state-of-the-art venue for the performing arts. While such groups as the Aspen Santa Fe Ballet, the Santa Fe Chamber Music Festival, the Santa Fe Symphony Orchestra and Chorus, and others, were doing their best to perform in the city's charm-

**225 West San Francisco Street
(505) 988-1234
www.lensic.com**

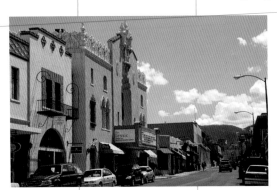

ing (but admittedly "intimate" and/or technologically challenged) churches, chapels, college theaters, etc., there simply was no venue where the acoustics, stage, lighting, and sound were specifically designed for performance arts and that could hold an audience sizable enough to bring in a profit. So, the decision was made to transform the historic theater into the Lensic Performing Arts Center.

A rapt local population followed the progress as the back of the building was removed and the stage expanded; as the Advanced Control System, which adjusts to accommodate specific acoustic needs was installed; as cherished architectural and design elements were painstakingly restored. This was to be Santa Fe's own cultural landmark and milestone—a venue for the new century of theater, music, dance, film, lectures, and community events. The doors reopened in April 2001 to a standing ovation from a grateful city.

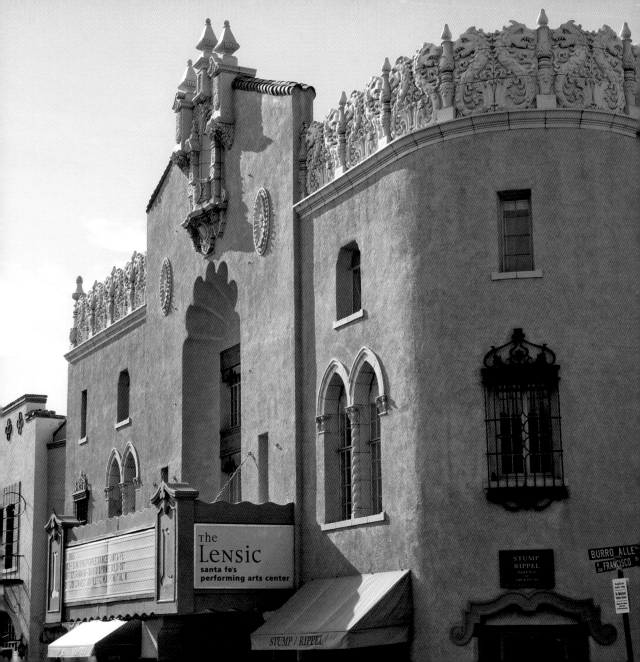

ACÉQUIA MADRE

Santa Fe's history, culture, and natural beauty intersect on Acéquia Madre, a romantic *camino* that meanders alongside its namesake, the venerable Acéquia Madre (mother ditch) just east of the downtown area. Hand-dug more than 400 years ago to deliver water from the Santa Fe River to the orchards and fields of old Santa Fe, the mother ditch is a cherished historical artifact.

The fields are gone now, but glistening waters still flow through the acéquia (ah-SEH-kyah), one day a week throughout the growing season, to the gardens and old-growth trees framing the road. The stone-lined ditch isn't the only vestige of Santa Fe's agrarian past to be found in the neighborhood. Several of the unpaved lanes that end at Acéquia Madre Street began as *brechas,* easements that bordered the typically long, narrow plots of land, allowing access to the crops. These include San Antonio, San Pasqual, La Paz, Manzano, and Sosoya lanes, across the street from Acéquia Madre Elementary School, where a mural on the west wall depicts the life-giving, life-affirming role of acéquias in a desert landscape.

Echoes of a Spanish Colonial past are evident in adobe-brick homes built in the shape of an L or U, with portals, courtyards, small windows, and vigas (de-barked logs) supporting thick roofs (originally made of twigs and earth). The influence of an early building concept—the family cluster or compound (which left more land for farming)—survives as well in the early-to mid-twentieth century compounds that grace the area.

Acéquia Madre evolved slowly throughout the late-nineteenth and early-twentieth centuries, reflecting the architectural tastes of newcomers who arrived after New Mexico became a U.S. Territory in 1848. Pedimented lintel windows and door frames, brick coping and white-painted, milled wood trim and picket fences appeared at this time. Within twenty years of New Mexico's achieving statehood in 1912, Acéquia Madre had transitioned from pastoral byway to neighborhood street.

Yet, apart from a couple of businesses on Garcia, a side street, and the occasional car or truck, there is little to reflect a twenty-first-century presence.

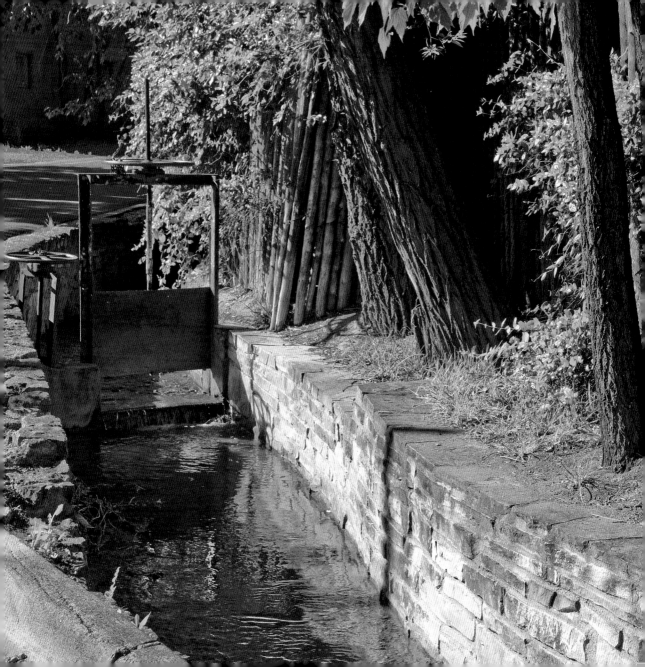

SANTA FE FARMERS MARKET

For many people, Saturday and Tuesday mornings belong to the Santa Fe Farmers Market, one of the top-ranked farm-to-table markets in the country. Its corner of the city's Railyard District buzzes with activity, with more than a hundred vendors and thousands of customers contributing to a festive mood. The market usually features music, educational demonstrations, lots of chatter, the chance to greet friends old and new, and, of course, a photo-perfect variety of farm-fresh, Northern New Mexico produce, organic meats, cheeses, breads, ciders, fresh flowers and plants, honey and jams, and more.

Early arrival is recommended. No need to eat breakfast first; just grab your shopping bags and go. Burritos, rolls, and strong coffee are always available, along with piles of free samples!

This farmers' market has been around since the 1960s, when a small group of growers began gathering to sell produce out of the back of their pickup trucks. Over the years, the laid-back

Farmers Market 1607 Paseo de Peralta at South Guadalupe Street www.santafe farmersmarket .com

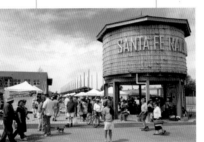

coalition has morphed into a sophisticated organization, setting regular dates and times of operation and rules about what can and can't be sold.

Every stick and stalk sold at this farmers' market must be locally grown, and it must be sold by the growers—no resale. The ingredients for agricultural crafts, herbs, teas, condiments, etc., must be at least 80 percent locally produced. These rules ensure that Santa Feans are supporting the small-farm economy that enriches life in the region. Over time, customers and growers establish caring relationships.

Santa Fe Farmers Market has been at or near its present location off of South Guadalupe Street since the 1980s. The arrangement was formalized when the market became an anchor of the city's Railyard District, dedicated in 2008. Now it's housed in its own pavilion and open for business and other activities year-round. This market attracts about 160,000 residents and visitors annually and is a must-stop in the City Different.

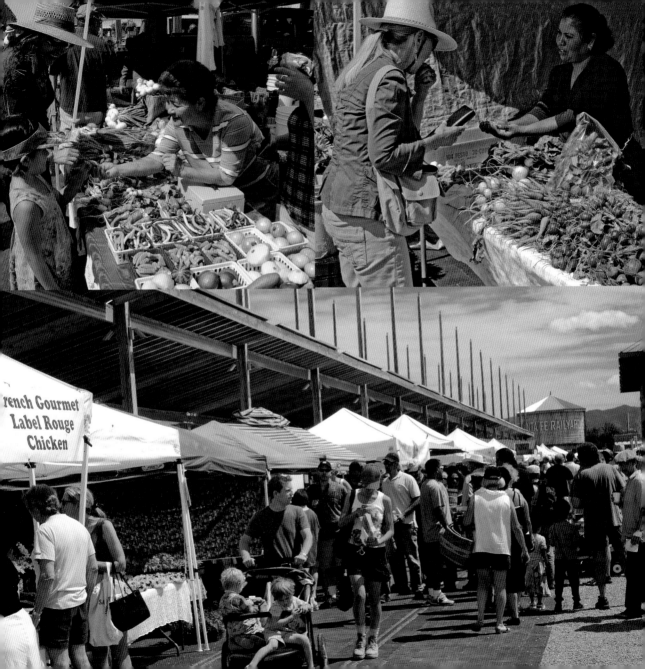

SANGRE DE CRISTO MOUNTAINS

The Sangre de Cristo Mountains run north to south from Colorado to a rounded sweep of peaks and valleys that end east of Santa Fe at Glorieta Pass. Actually a sub-range of the Rocky Mountains, the "Sangres" apparently rose from the earth as a single piece of rock 27 million years ago, in some cataclysmic geologic event. Despite its violent past, this magnificent—and beneficent—range forms the backbone of North Central New Mexico, with its mountain villages, granite summits, lakes, streams, and forests. Life on the high-desert plain would be vastly different without the long, green monolith that supports wildlife and provides firewood and pastures to those who depend on the land.

In the fall, the entire range is streaked with gold as the aspens perform their autumnal ritual. In your pilgrimage to view the leaves, you will notice that the cedar and piñon forests of the foothills give way to pine and fir at higher elevations, and finally, to the powerful

Maps and Information: Santa Fe National Forest www.fs.fed.us/r3/sfe/

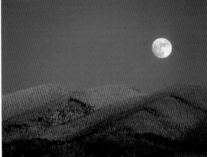

granite peaks and scrabble above the tree line. There are ten peaks over 14,000 feet high in the range, and more than two dozen over 13,000 feet.

In Santa Fe, the Sangres slowly deliver the dawn as it creeps over the peaks, and they reflect the showy fires of sunset. They chart the course of our hours and anchor our lives. But it's such a strange name: Sangre de Cristo, Spanish for "Blood of Christ." While theories abound as to the origin—including the reflection of red sunsets on snow-blanketed slopes—no maps from the Spanish Colonial period refer to the mountains by that name. One oft-repeated theory suggests it came from the lips of a humble padre who died while witnessing the mountains transform to the color of blood. "Sangre de Cristo," he uttered, his last, redeeming words. Some say the phenomenon is called "alpenglow" in other parts of the world, but, as fraught with meaning as it is here, it's difficult to imagine experiencing it the same way anywhere else.

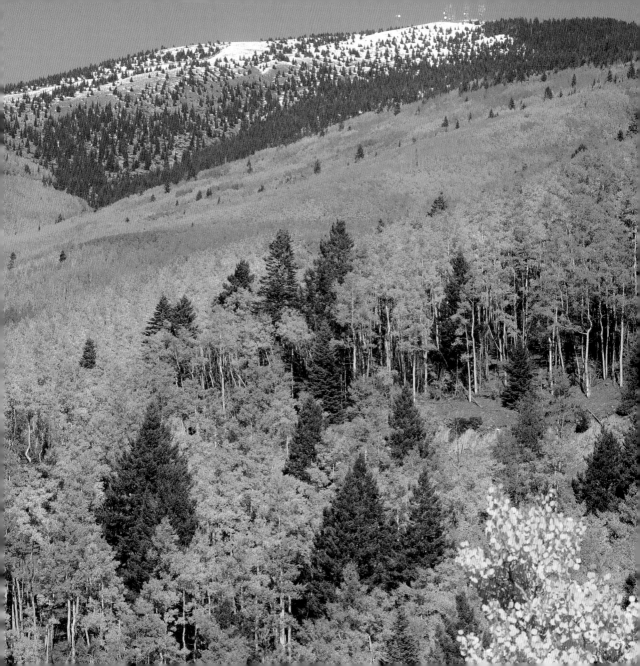

COYOTE FENCE

Finally, the ubiquitous "howling coyote" that has starred in Santa Fe souvenir shops for years has "exited the building," another class of trinkets relegated to the kitsch hall of fame. Never fair to the coyote and a disservice to the culture of this artistic city, the iconic images that appeared on everything from jewelry to T-shirts, aprons, and hats won't be missed by Santa Feans.

Coyote, after all, is the famous "trickster" of Native American and Southwest folklore, nature's equivalent of a street-smart hoodlum. Reputed to be smarter than the smartest dog, and able to outwit most men, this predator of the prairie deserved better representation. It was the coyote's ability to get around, underneath, or over existing types of fences that led frontier settlers to create a better barrier against recurring attacks on their livestock, poultry, pets—and even children. Using available resources, they designed a fence made of tall, slender poles called *latillas* (lah-TEE-ahs), wired together tightly or mounted on frames to secure small areas

*Coyote
Fencing Supplies
Rowe
(505) 757-8555*

such as pens or coops. Around Santa Fe, settlers found aspen, cedar, and pine in abundance, and, leaving the rough bark intact, they crafted their fences from this material.

There are still plenty of coyotes in the hills and scrub surrounding Santa Fe—their haunting songs still thrill the night air—but it's not the security of property that drives the current demand for the rustic fences. Simply put, coyote fences are the perfect complement to the sculptural adobe architecture and native plantings that comprise our domestic landscape. Chamisa, aster, lilacs, hollyhocks, and clusters of heavy-headed sunflowers all display best against the rough backdrop of a coyote fence. When paired with long, low curves of adobe wall, these linked latillas add texture, privacy, and interest.

Born of necessity, coyote fences have come a long way since frontier days, yet they continue to serve their owners well. And they make better symbols of Santa Fe's cagey canine than the howling coyotes ever did.

THE MIRACLE STAIRCASE

Everyone loves a mystery. Since 1878, the spiral staircase at Loretto Chapel near the end of the Old Santa Fe Trail has provided one for Santa Fe.

Modeled after La Sainte-Chapelle in Paris, the chapel was originally part of Loretto Academy, a girls' school run by the Sisters of Loretto, true education pioneers who came to Santa Fe when New Mexico became a U.S. Territory in the mid-1800s. It cost $30,000 to build, and it's believed the sisters pooled their inheritances to pay for it. Imagine their dismay when they discovered their beautiful chapel was too small to provide the required space for a staircase leading to the choir loft, 22 feet above the floor!

These sisters had braved the dangers of prairie travel, cholera, and the death of a Mother Superior to get to Santa Fe and answer the call for preachers and teachers in the new territory. But they

Loretto Chapel
211 Old
Santa Fe Trail
www.loretto
chapel.com

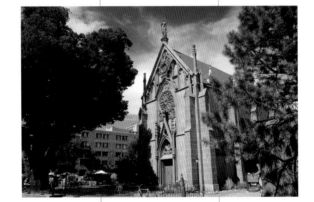

couldn't get beyond this challenge.

Then, after nine days of prayer to St. Joseph, patron saint of carpenters, a man appeared, carrying a toolbox and asking for work. Summarily dispatched to the chapel, he labored for months, creating an intricate spiral staircase. Then he disappeared without asking for pay. The sisters searched in vain for the carpenter, finally daring to believe it had been St. Joseph himself who'd built their staircase.

More mysteries surround the construction of the staircase, especially given the tools and technology available at that time. The staircase has two 360-degree turns and no visible means of support. The wood used to construct the staircase does not grow in the area, so where did it come from? The story of the "miracle staircase" spread far and near, bringing untold numbers of people to Santa Fe to witness the 140-year-old mystery.

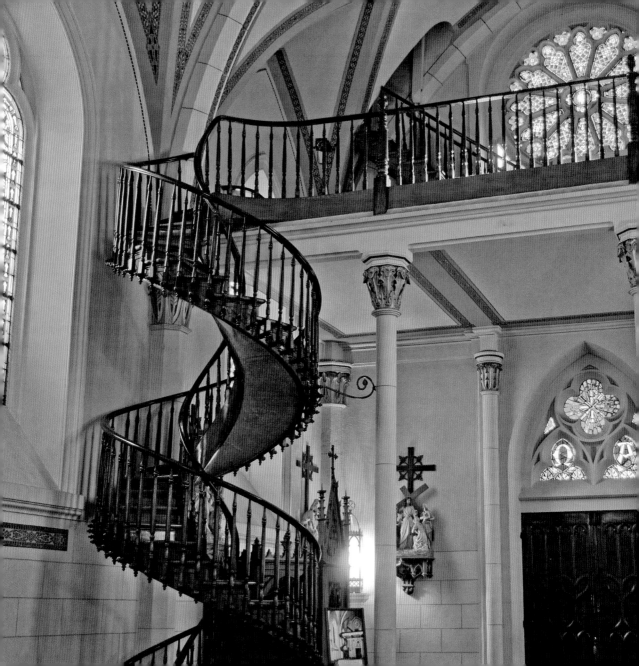

BURRO ALLEY

It's a big deal to have a street named after you. Pedro de Peralta, the founder of Santa Fe, has his *paseo,* and Don Diego de Vargas, who re-colonized Santa Fe following the Pueblo Indian Revolt of 1680, has his namesake street. St. Francis of Assisi has two, and in different languages (San Francisco Street and St. Francis Drive), but then, he's the city's patron saint.

These are worthy people who rate space in history books. But what of the laborers upon whose backs society was built? Happily, Santa Fe reserved a street (okay, an alley) for one of them: the burro, the beast that once hauled construction materials, commercial goods, and firewood through the streets of Santa Fe before the advent of delivery trucks. The burro hauled it all, winter and summer, so Santa Fe immortalized him in bronze, perpetually laden with firewood, at the corner of San Francisco Street and Burro Alley.

Read more about Doña Tules: The Wind Leaves No Shadow by Ruth Laughlin

Café Paris 31 Burro Alley (adjacent to Lensic Theater)

Old photographs of the Plaza area reveal that Burro Alley was once a busy, unpaved pathway lined with burros parked at a long hitching post. People rushed by, then as now, using the alley as a shortcut between streets north and south of the Plaza. Today, Burro Alley is home to Café Paris, a restaurant and bakery, where accordion music and long strings of twinkly lights enliven the now-cobbled alley after dark, and gay umbrellas invite leisurely lunches in the summertime.

Speaking of leisurely lunches, back in the mid-1800s, a door in Burro Alley provided a discreet entrance to a famous brothel owned by Santa Fe's legendary Doña Gertrudis de Barceló. The girls of *la casita mala* (the bad house) would walk the alley to drum up business. Sadly, there's no street name or statue in Santa Fe to honor "Doña Tules" or the working girls now lost to history.

CHILE, RED OR GREEN

A narrow gauge railroad that ran from Santa Fe to Antonito, Colorado, until 1941 was nicknamed the "Chili Line" because it followed the Rio Grande through pueblo and village farms where fat, fiery-red strands of chile hung drying on every available wall and roofline, ensuring a winter of good eating.

Then as now, a *norteño* family could no more survive a season without chile as it could sustain a life without love. For many, they are one and the same. Even today, a chile ristra hanging from a rafter or doorway sends the timeless message of warmth and well-being within.

Chile comes in all shapes, sizes, and degrees of heat, but for practical culinary purposes, it is either red or green, the green being long and fleshy and arriving in Santa Fe, ready for roasting, on huge trucks from August through September. This commercial variety hails mostly from the southern

Seeds of Change
Research Farm
www.seedsof
change.com

Chimayo Chile
Project (on
YouTube)

part of the state, from fields in or around the now-famous town of Hatch.

Red chile is fully ripened and comes from the same plant that provides the green. However, to the north of Santa Fe, in mountain villages and valleys, red chile production assumes a more-traditional aspect. Small farms there strive to preserve the heritage chile descended from ancient stock. This tends to be smaller and not as perfectly formed, but its taste is richer, recalling the sun, earth, and water of the home farm. The best red chile powder comes from this area. Rarely sullied with "fillers" used elsewhere, its color is the richest red, and its aroma, heady. You'll never settle for less again.

But be warned: Chile—either color—is addictive. Eating it releases endorphins, which trigger feelings of pleasure. The more chile consumed, the greater the effect, until you just can't live without it.

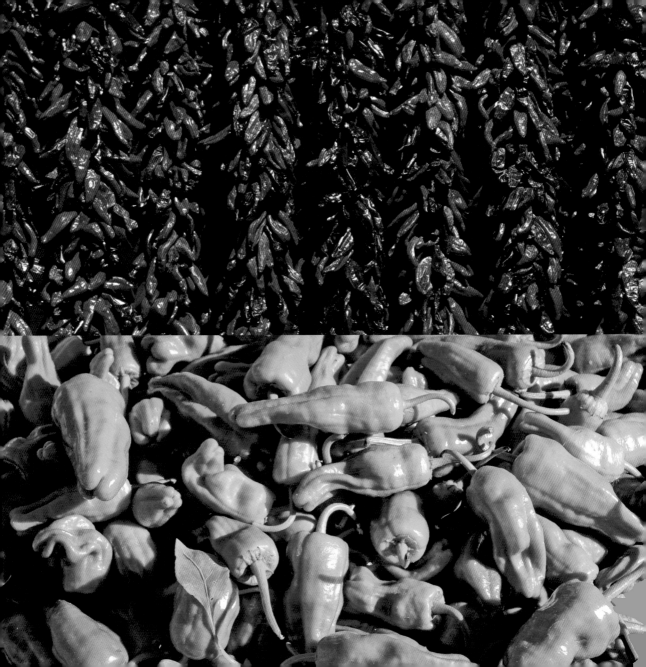

SANTA FE OPERA

Santa Fe Opera opened its 2001 season on a perfect summer evening with Gaetano Donizetti's *Lucia di Lammermoor,* a bel canto favorite set in Scotland. Many patrons arrived early for the traditional tailgate supper in the parking lot prior to the performance, and anticipation was high.

Gradually, the distant sound of bagpipes replaced conversation, a siren call to begin the approach to the theater. There at the entrance stood a striking gauntlet of kilt-clad bagpipers, through which the audience would pass. A sprinkling of male patrons also had donned kilts and tuxedo jackets, adding to the air of fantasy.

From its perch on a mesa top, the open-air opera house affords unobstructed views of the Jemez Mountains to the west and the Sangre de Cristos to the east, vistas that many stage designers incorporate into their sets. On this night, a fading orange sunset formed the backdrop from behind the stage. The first stars twinkled and silence fell. The conductor raised his baton.

SFO
U.S. Highway
84/285
7 miles north
of Santa Fe
boxoffice@santafe
opera.org

All this—and the overture had yet to begin!

That was years ago, but the memories of that—and of so many other opera nights—linger and are shared again and again in Santa Fe. SFO creates more than seasons of great entertainment; it creates a culture to sustain the art form into the future.

Despite the festival atmosphere, SFO is a year-round opera company. Besides its highly acclaimed summer productions of standard, contemporary, and experimental opera, SFO apprentice programs for singers and technicians are world-renowned. The opera collaborates with musical organizations such as the Santa Fe Chamber Music Festival in community outreach and education programs throughout the year.

In 2009, Charles MacKay accepted the reins as general director of the SFO, only the third person to hold that position in the opera's fifty-plus-year history. Such continuity and commitment to SFO, and to opera, greatly benefits both Santa Fe and opera fans.

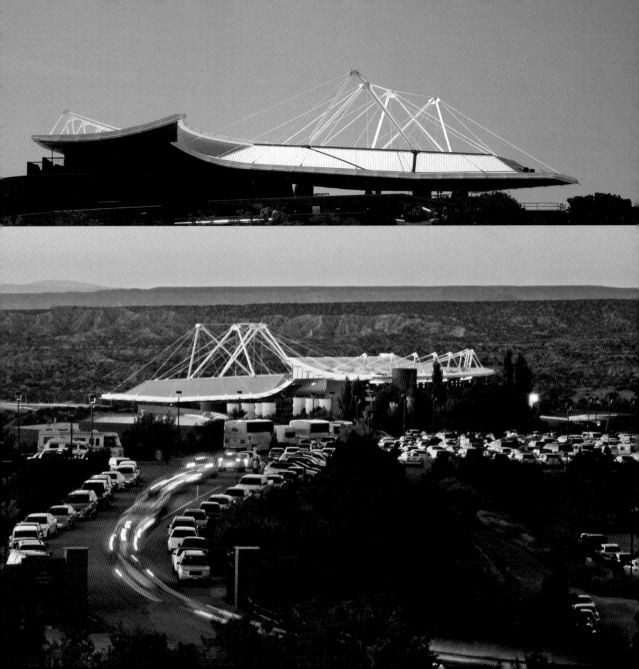

THE RAILYARD DISTRICT

Santa Fe isn't only about "old things." The fifty-acre Railyard District, which opened in September of 2008 after decades of planning, is a burgeoning center of contemporary art, sustainable architecture, and social interaction with a city vibe. There are lofts to live in, commuter and "fun" trains to ride, shops, restaurants, nightclubs, a farmers' market, and a park—all on what had once been the last expanse of open land in the downtown area. The city bought it before it could be parceled away and let the community decide what to do with it.

Anchored by the historic Santa Fe Depot—now a commuter train station and the home of Santa Fe Southern Railway, a vintage train that runs between Santa Fe and Lamy—the district took shape slowly, preserving existing assets and courting new enterprises.

There was never doubt that SITE Santa Fe—a contemporary art space

*Santa Fe Depot
410 Guadalupe
Street*

*Railrunner
Express Station
(866) 795-RAIL*

*Santa Fe
Southern Railway
(888) 989-8600*

that hosts a *bienale;* El Museo Cultural, a center for Hispanic arts; and Warehouse 21, a nationally acclaimed teen center—would remain in their respective locations. Trendy Sanbusco Market Center, with its eateries and upscale shops, was another longtime Railyard resident that wasn't going anywhere. In the late 1800s, Santa Fe Builders Supply Company (Sanbusco) was one of the first businesses built along the new AT&SF railroad line; it grew to include a cluster of warehouses, now restored as the market center. That "Western warehouse" aesthetic set the design pace for the Railyard's new, clean-lined galleries of contemporary art.

When the Railrunner Express finally began its commuter service to Albuquerque and points south in December of 2008, local hearts swelled to see the shiny train emblazoned with its iconic roadrunner gliding through the Railyard, connecting the city to its railroad past—and future.

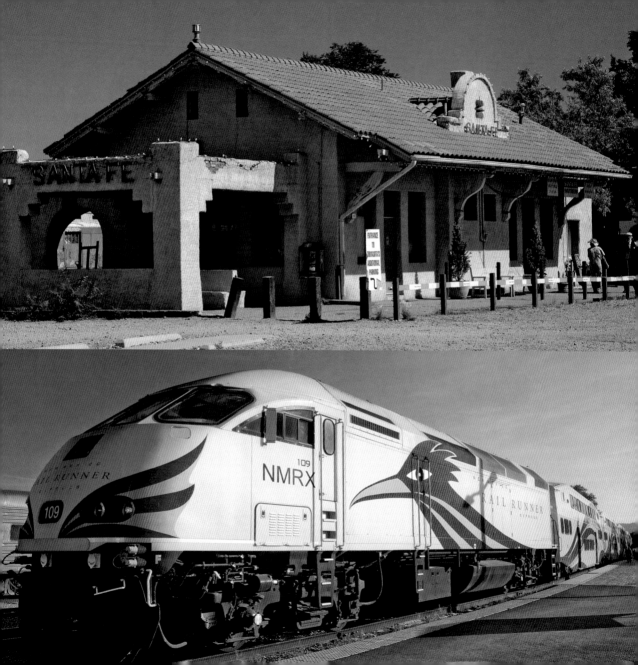

PALACE OF THE GOVERNORS

The long portal at the Palace of the Governors bustles with activity from early morning, when Native American artists arrive to secure a place along the wall, until dusk. More than 900 vetted vendors representing New Mexico pueblos, tribes, and the Navajo Nation are eligible to participate in the Native American Artisan Program, which employs a daily lottery to decide who can spread their wares on blankets under the portal to tempt shoppers, who must stoop to examine their goods or speak to the artists. This unique way of shopping for authentic Native arts and crafts is a long-standing tradition embraced and honored by New Mexico residents and visitors.

While the colorful artisan market steals the show, it's important to remember that the Palace of the Governors is the oldest continuously occupied public building in the United States. It's literally a historic artifact of the adjacent New Mexico History Museum.

Construction of the Palace began in 1610, when Santa Fe was declared the

New Mexico History Museum 113 Lincoln Avenue (505) 476-5200 www.nmhistory museum.org

seat of Spanish provincial government. It has flown four flags—the Spanish until 1821, the Mexican until 1848, the American Confederate, and the Stars and Stripes. Indians occupied the building for about twelve years following their revolt in 1680, using it for housing. The Palace currently exhibits a collection of Spanish Colonial art.

Together, the museum, which opened in 2009, the Palace of the Governors, and the Fray Angelico Chavez History Library and Photo Archives comprise the New Mexico History Museum campus, the realization of a dream to make the historic Plaza area a premier resource center for American Southwest studies. The museum covers the progress of humankind in the region, from the earliest Natives through the Manhattan Project, using interactive exhibits, stories, and personal narratives to engage visitors in a personal way. A room filled with photographs from all over the state ends the exhibit on a contemporary note.

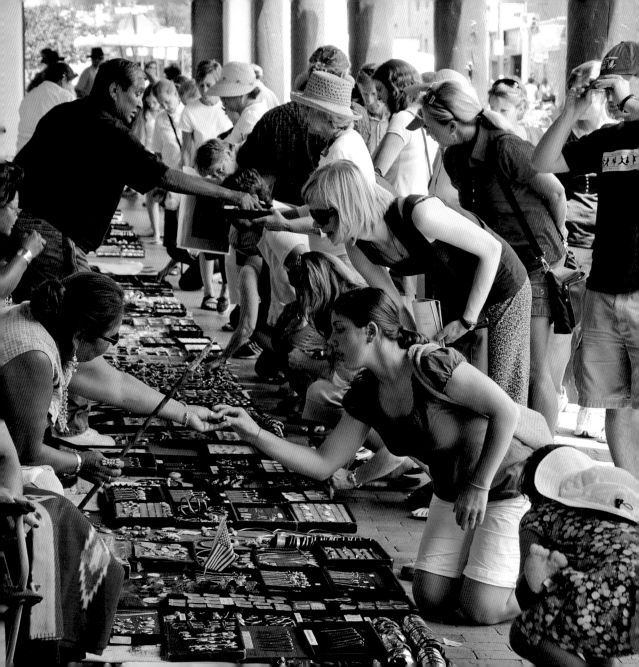

ZOZOBRA

Those who weren't raised thinking it's okay to torch a huge marionette as it writhes in pain and flails in fear might find their first Zozobra burning macabre, if not downright scary. Santa Feans have been doing this since 1924, when a group of artsy types decided to create a secular diversion for Fiesta de Santa Fe, a historically religious observance.

What began as a backyard burning, possibly a private celebration at artist Will Shuster's east-side abode, has become a highlight of Fiesta, attracting about 20,000 people each year to a field north of the Plaza, where they get to yell "Burn him, burn him!" at the appointed moment, initiating the demise of a 50-foot-tall (give or take) effigy, along with a year's worth of collective gloom and doom.

Zozobra, in fact, is Spanish for anxiety or worry. At this event, the community is invited to project their cares onto the puppet, which is destined to go up in smoke and take the worries with it. Some take the idea literally, stuffing a "gloom box" with such hard-copy proof of woe as divorce papers, foreclosure and

To add your gloom:
gloom@zozobra
.com

To follow
Zozobra:
#oldmangloom
at twitter.com

bankruptcy statements, Dear John/Jill letters, etc. The box, in turn, is stuffed inside Zozobra prior to ignition.

The Kiwanis Club took over the ritual in the 1960s as a means of supporting its charitable and civic projects. A dedicated cadre of volunteers works year-round to ensure a successful performance and oversees the building of the hapless giant in the days before Fiesta.

On burning day, revelers descend on the field with blankets and umbrellas and perhaps a picnic supper to share in the shadow of Zozobra, who appears to rest peacefully on supportive scaffolding. Once the sun sets, however, some primal trigger (a genetic memory, perhaps?) awakens the sleeping giant, eyes aglow; the crowd springs to life, primed to deliver its inevitable verdict—*Burn him*—as punishment for a year's worth of anxiety-making mischief. Zozobra expires in a pyrotechnic orgy, illuminating the antics of fire dancers and assorted gyrating gremlins below. Sated, the crowd enters Santa Fe's version of New Year's Eve, free, for the moment, of fear and foreboding.

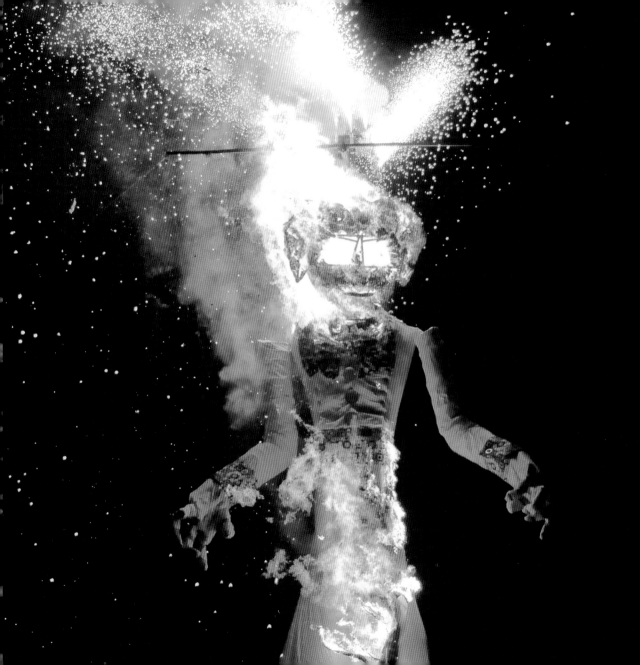

THE OLDEST CHURCH

San Miguel Mission, located at the corner of East De Vargas Street and Old Santa Fe Trail, is the oldest church in continuous use in the United States. Tlaxcaltecan Indians, allies of the Spanish who accompanied the first colonists here in the early 1600s from what is now central Mexico, built the church and surrounding neighborhood. They farmed the banks of the nearby Santa Fe River and provided much of the labor that built Santa Fe. Many worked as servants in Spanish homes.

San Miguel
Mission
401 Old
Santa Fe Trail
(505) 983-3974

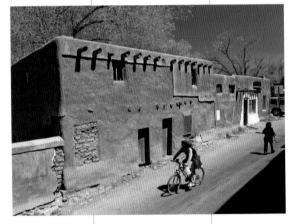

The Indians named their compound the Barrio Analco, combining the Spanish word for district (*barrio*) with *Analco,* which means "the other side of the water" in Nahuatl, their native language. Just as railroad tracks once separated towns socially and economically, so did the river in old Santa Fe. The Spaniards lived on the north side of the water, the Indians on the south. Spanish soldiers who returned with Don Diego de Vargas in 1692 to reclaim Santa Fe after the Pueblo Indian Revolt effectively integrated the barrio and the mission church.

San Miguel, where mass is still celebrated on Sunday evenings, houses many precious artifacts, including a wooden altar screen that holds a statue of St. Michael from the early 1700s. The San José Bell, weighing nearly 800 pounds, is believed to have been cast in Spain in 1356.

Plaques on houses on De Vargas Street help locate some of the important structures in Barrio Analco, a National Historic District. One of the oldest is the Gregorio Crespin House, built sometime after 1720 (according to tree-ring dating of its interior beams) and sold in 1747 for 50 pesos. The popular Santa Fe Playhouse on De Vargas Street was founded by writer Mary Austin in the 1920s.

FAROLITOS

All is calm; all is bright . . .
The composer of "Silent Night" could have been dreaming of a Santa Fe Christmas, where the holiday is filtered through the soft glow of candlelit paper lanterns, called *farolitos,* and the dancing flames of small bonfires, *luminarias.* Although farolitos are gaining in popularity all over the country, their display elsewhere cannot come close to the one that has become a Santa Fe tradition: the farolito walk on Christmas Eve, along famous Canyon Road and in the adjacent historic neighborhoods.

There, thousands of farolitos provide the only light. No cars are allowed between specified hours, so there's nothing to detract from the enchantment of the scene. Homes and galleries along the way, some offering cider and hot chocolate with good cheer, greet the throngs. Songs ring out as clusters of carolers pass by on their way to warm themselves by the occasional bonfire.

Traditionally used to light the way to village churches on Christmas Eve,

The Farolitos
of Christmas
by Rudolfo Anaya

Christmas in
Old Santa Fe
*by Pedro Ribera
Ortega*

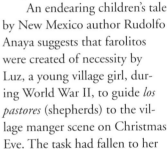

la noche buena, there is debate over where and when the farolito tradition began. Some say the idea came from the paper lanterns used by Chinese laborers, observed when they came through New Mexico to lay tracks for the railroad. And *farolito* does mean "little lantern" in Spanish, so *quien sabe?*

An endearing children's tale by New Mexico author Rudolfo Anaya suggests that farolitos were created of necessity by Luz, a young village girl, during World War II, to guide *los pastores* (shepherds) to the village manger scene on Christmas Eve. The task had fallen to her after her grandfather's illness precluded his annual building of guiding bonfires. Inspired by a candle in the window, Luz figured out that by placing votives in small bags and setting them up to light the way, she could save Christmas, even as she battled her own dark fears and longing for a father away at war.

Whatever their origin, the purpose of the illuminations is to guide the path to peace and joy, just when a dark and cold world needs them most.

THE TURQUOISE TRAIL

Heading south from Santa Fe on NM 14, also called the Turquoise Trail, an archipelago of hills and buttes diverts the eye from an otherwise seamless vista of sky and high-desert plain. These are the *cerrillos* (hills) of bygone fame and fortune that today shelter the old mining towns of Cerrillos and Madrid along a 60-mile national scenic byway to Albuquerque.

Cerrillos, about a thirty-five-minute drive from Santa Fe, was once known as the richest source of turquoise on the continent. The first miners were Indians, who held the blue-green stones in high regard for both ritual and trade. Spanish settlers also mined the turquoise, but it wasn't until after New Mexico became a Territory of the U.S. in 1848 that the extractive industry—with its aggressive technology—fully exploited the turquoise, coal, lead, silver, and gold found in this geologically unique area.

The hills today are riddled with old turquoise mines, some now part of the Cerrillos Hills Historic Park, where there are marked trails to some of the mines

Maps and Information: www.turquoise trail.org

along a dirt hiking and biking trail. A mining museum and trading post in the village provide a starting point for exploration.

Three miles down the road is Madrid, which boomed when rare deposits of both soft and hard coal were discovered. Many Santa Feans can claim family members who worked the mines within living memory. They recall the company mercantile, ballpark, and extravagant Christmas displays, which glowed brightly thanks to coal-generated electricity. The coal mines shut down around 1950, and Madrid became a ghost town, the doors of miners' shacks slapping in the wind, saloons and boardinghouses silent. It stayed that way for about twenty years, until a group of intrepid homesteaders/artists seeking an alternative lifestyle moved in. Today, Madrid supports a thriving art colony, a coal mine museum, and a tavern in a vintage setting. The Turquoise Trail takes visitors back to another time, where vestiges of the Old West linger.

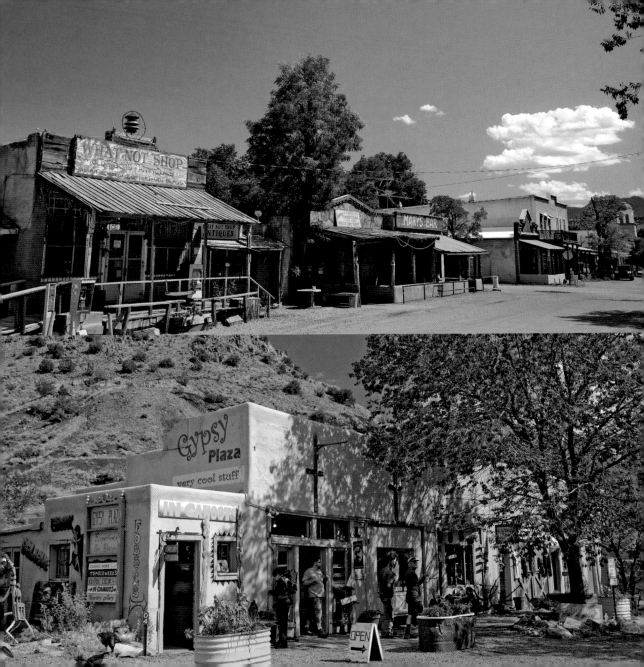

ADOBE

It's said the best things in life are free. Dirt, sun, and straw are certainly free, and yes, they do make some of the best and most beautiful buildings in the great Southwest. Adobe construction was about the only type of building done in Santa Fe through the early twentieth century, when it was largely replaced by "adobe look-alike" materials (also called *fauxdobe*). But the exploding green building and sustainability movements have rekindled interest in earthen-building methods, including the layering of simple, sun-dried bricks.

Adobe-making workshops are springing up all over the country, and colleges are offering classes in adobe-making and mudding. The construction industry is also awakening to the possibilities and is rushing to test and approve adobe construction standards compatible with local needs.

There's more than sustainability to adobe, however; its use gave rise to rituals and traditions still practiced in corners of New Mexico, where each vil-

The Adobe Factory Alcalde mel@adobefactory.com (505) 852-4131

Adobe Man, Santa Fe (505) 986-3995

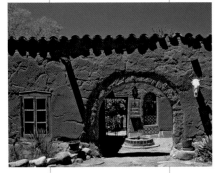

lage or pueblo developed its own blend of earth and straw and claimed its own "special place" from which to dig the earth for plasters to mud the bricks. The recipes for mixing and techniques for applying earthen plasters were passed from mother to daughter in the *enjarradora* tradition, and are fast disappearing from community memory. Organizations involved in the restoration of old adobe structures are interviewing elders and analyzing the old bricks before the lessons of adobe are lost.

Latter-day brick makers may add a stabilizer, such as asphalt emulsions, to make the brick more water-resistant and durable, but other than that, the soils and sunshine of the Southwest still result in the best bricks. And they're still made in the old way here, mixing earth with straw and whatever amendments are required, pouring the mud in forms, and laying them in the sun to dry. Adobe brickyards can produce thousands of premium-quality mud bricks a day, using the traditional methods.

POSOLE

A holiday open house or office potluck in New Mexico that fails to welcome guests with a comforting, redolent bowl of *posole* (poh-SOH-leh) is definitely lacking. It's more than a tradition; served alone or as a side dish, this slow-simmered pork, hominy, and red chile stew is the hallmark of an authentic New Mexican kitchen.

Restaurants that don't offer posole, along with red and green chile dishes, may not qualify as New Mexican eateries at all, but as Tex-Mex, Cal-Mex, or Mexican. While these represent a growing and welcome addition to the Santa Fe food scene, if authenticity is key, rice is nice, but posole is holy!

When the Museum of New Mexico Foundation compiled *Santa Fe Kitchens,* a cookbook to raise money for its projects, it asked dignitaries, chefs, and restaurateurs to contribute recipes they felt honored the local kitchen traditions. Governor Bill Richardson sent in his famous posole recipe, no doubt served at the mansion to a pantheon of the world's movers and shakers.

To Order Ingredients:
www.bueno foods.com

Richardson's Red Chile Posole

1 pound frozen posole
1 onion, chopped
2 pounds boneless pork roast, cubed
1 clove garlic, minced
1 cup red chile sauce (see below)
½ teaspoon oregano
Salt and pepper to taste

Red chile sauce: Heat 2 tablespoons of lard in medium saucepan on medium heat. Stir in two tablespoons of flour and cook until golden brown. Add ¼ cup of New Mexico red chile powder and cook for an additional minute. Gradually add water and stir constantly, making sure no lumps form. Add ½ teaspoon of garlic salt, 1 teaspoon of salt, and oregano (optional) to taste. Simmer at low heat for ten to fifteen minutes.

Red chile posole: Rinse posole several times. Place onion and garlic in large Crock-Pot and fill with water, leaving room for posole. Cook over medium heat for thirty minutes; then add posole and cubed pork. Cook on high for several hours until posole has "blossomed" and pork begins to fall apart and is tender. Add water as necessary to prevent scorching. Add red chile sauce, oregano, salt, and pepper. Cook for another ten to fifteen minutes. Serve garnished with chopped green onions, chopped cilantro, and quartered limes. Serve with fresh, warm tortillas or corn bread. *Buen provecho!*

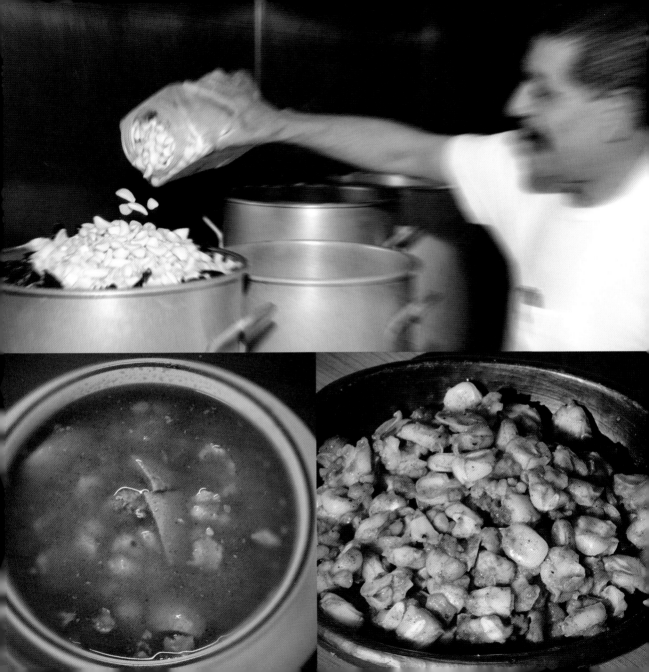

TEN THOUSAND WAVES

For a spa, Ten Thousand Waves is a busy, happening place. The well-planned and professionally staffed bathhouse moves a steady flow of guests through its doors each day. The waiting area, where robed guests sip herbal tea and enter the languid zone of the well cared for, is usually quite full. People know to call ahead for a soak or massage.

One doesn't go to Ten Thousand Waves to get away from it all, but to affirm that relaxation is an integral part of a healthy lifestyle. That is the Japanese ideal, and the one on which Ten Thousand Waves, a Japanese-style bathhouse, is based. So while other spas may focus on a particular element of wellness—say, diet, beauty, or alternative health care—"Waves" is just an easy, comfortable (albeit well-appointed and naturally beautiful) place to unwind with like-minded people.

3451 Hyde Park Road
(505) 982-9304
www.tenthousand waves.com

That's been the point since 1981, when Ten Thousand Waves opened as a cluster of outdoor hot tubs on a hill overlooking Santa Fe. About a ten-minute drive up the ski basin road, Ten Thousand Waves pulls in skiers heading down the mountain and locals heading up after a long day's work.

For many visitors, Waves is a mandatory stop on any visit to Santa Fe.

There are enough options at Ten Thousand Waves to suit just about any schedule or pocketbook, progressing from an inexpensive soak in the community hot tub (or the women-only pool) to private tubs and a full menu of specialized treatments. For those who wish to stay overnight or longer, there is lodging available in Japanese-style houses, with more options on the way. Ten Thousand Waves makes it so easy to relax, there's no excuse not to.

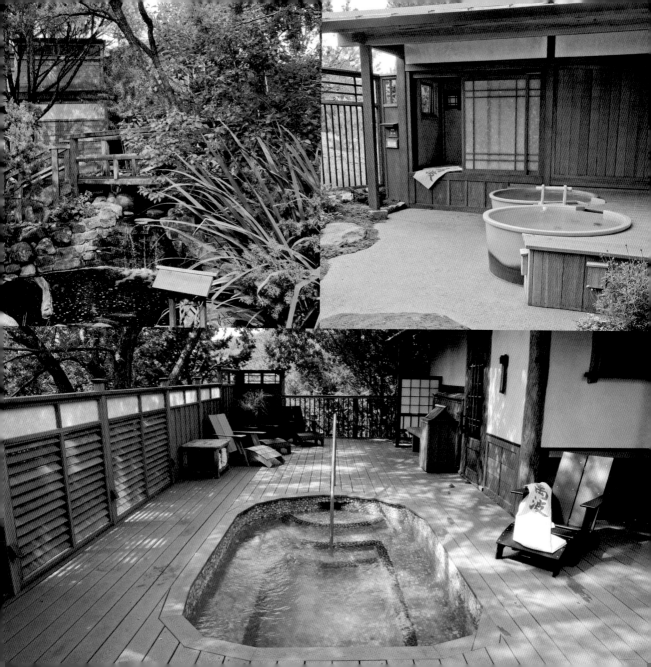

SPANISH MARKET

Every culture has its crafts, made by hand in simpler times out of need or want, and later exalted for the traditional values they embody. The Spanish Market held annually on the Santa Fe Plaza the last full weekend in July (and a smaller market in December) honors and promotes the Spanish Colonial crafts that have been produced in the Southwest since the arrival of the Spanish in 1598. The values and traditions of that culture are still very much alive, especially in Northern New Mexico, where families continue to pass on the knowledge of religious iconography, woodcarving, colcha embroidery, tinwork, weaving, etc., from one generation to the next.

Santeros (makers of religious folk art) hold a special place in these communities, creating beautiful religious icons, such as *bultos* (carved wood figures), *retablos* (paintings on wood), and straw-ornamented crosses.

Other crafts elevate the mundane, adding beauty to objects that families use every day. These folk artists trans-

Spanish Colonial Art Society/ Museum
Museum Hill
750 Camino Lejo
(505) 982-2226

form wool into elegant rugs and blankets, textiles into colorfully embroidered bedclothes and pillows, and tin into lamps that throw patterned light into dark corners. After centuries of intergenerational crafting, the objects take on characteristics unique to the families who make them. These are what collectors of Spanish Colonial folk art look for in their forays to Spanish Market.

A popular component of Spanish Market is the Youth Market, where the next generation of folk artists gets its start. Many collectors follow the annual progress of their favorite young artists, hoping to spot the next Ramon Jose Lopez, Irvin Trujillo, or Gloria Lopez Cordova. The spirit of family, of legacy, is very strong at Spanish Market, and is really the "art" most worthy of preservation.

The Spanish Colonial Art Society sponsors Spanish Market, and its museum houses the largest collection of Southwest Hispanic folk art in the world.

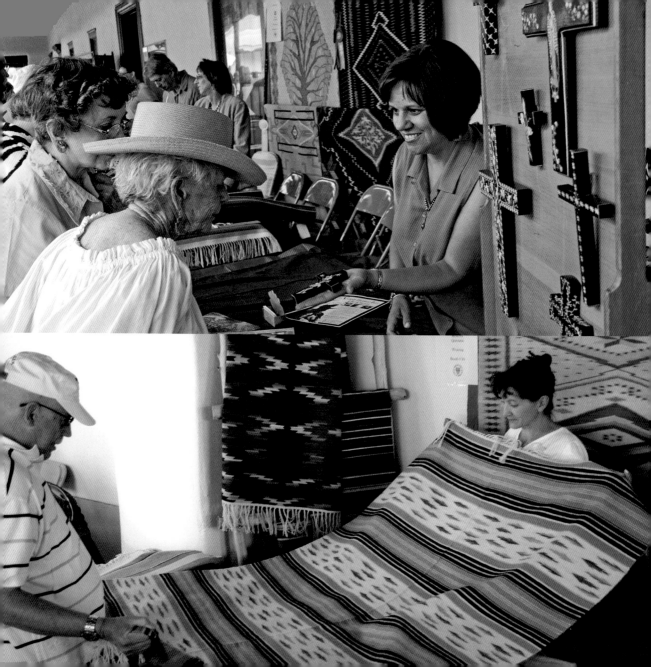

MARGARITAS

Santa Fe didn't invent the margarita, but its bartenders have taken it to a new level. The city has become the guardian of the margarita standards that made it the fiesta-perfect adult beverage in the first place.

While other cities boast margarita drive-up windows (no kidding; try the outskirts of New Orleans) and condone the high-proof "slushies" that ooze frozen facsimiles from whirring machines, Santa Fe stands staunchly by the original recipe and rules:

No. 1: Shake, don't blend. Except for fresh-fruit margaritas, which stand up better to extra liquid from melted ice, margaritas must never see the inside of a machine.

No. 2: Real margaritas are made of Mexican-certified tequila, real triple sec, and freshly squeezed lime or lemon. Who says so? Al Lucero, for one. He's the gregarious owner of Maria's New Mexican Kitchen, and a recognized national authority on the drink. Maria's

The Great
Margarita Book
by Al Lucero

Maria's New
Mexican Kitchen
555 West
Cordova Road
(505) 983-7929

bar boasts 160 margarita choices—all "real."

Tequila isn't open to definition, says Lucero. According to his *The Great Margarita Book,* if it isn't made in Mexico—where it's distilled from the sugary juices extracted from the cooked heart of the Weber blue agave plant, and certified by the government—it isn't tequila.

Period. The real stuff costs more than the copycats, but for the obvious difference in taste, quality (and frankly, effect), it's worth every penny. Lucero describes real triple sec as "a clear orange liqueur made from the skins of exotic orange peels, which have been sun-dried, then reconstituted with distilled water, fermented, then triple-distilled." (You wouldn't put that in a blender, would you?)

No. 3: Drink cheap or off-brand margaritas at your peril. (This one's not from Lucero, but from margarita fans.) You'll know at first sip if it's the "wrong" thing—and you'll know it doubly well in the morning. Insist on the best. *Salud!*

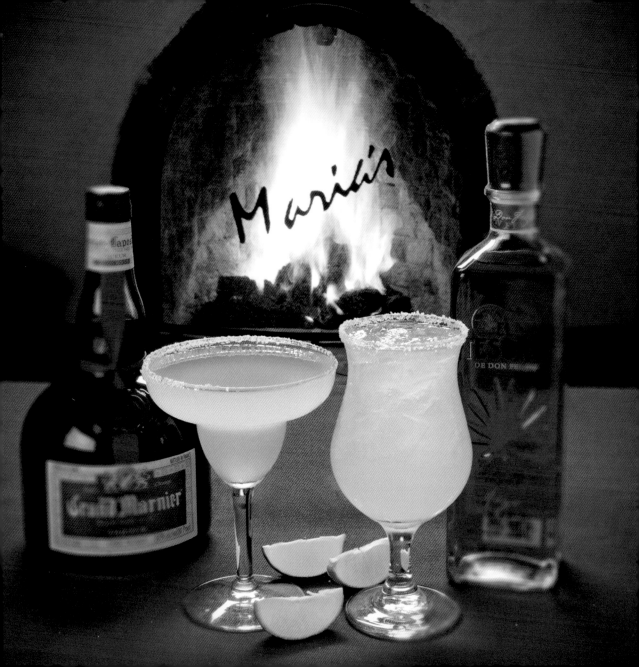

CANYON ROAD

Artists began moving to pictur-esque Canyon Road when it was still affordable—long before the city paved it in 1962 and designated it an arts and crafts district. One by one, they trans-formed the old homes into studios and galleries, retaining the genteel but funky ambience of old Santa Fe.

Today every type of art is repre-sented on Canyon Road, from tradi-tional Western and Native American to mid-century modern and contemporary. Quaint side streets and alleys along the way expand its boundaries. You'd be hard-pressed to find a more walkable and charming "commercially zoned" neighborhood anywhere.

A good time to begin an explora-tion of Canyon Road is on a Friday evening, when galleries tend to hold their art openings. Featured artists usu-ally attend these events, mingling with gawkers and collectors in a festive atmo-sphere. But the art parties are distract-ing, too; repeated day visits to Canyon Road galleries are the way to derive full benefit from this great artistic resource.

A perfect midpoint rest stop along the way is El Zaguan, a historic home

El Zaguan
545 Canyon Road

that was turned into an art colony. Mar-gretta Dietrich, sister of artist Dorothy Stewart, acquired the property and converted it into apartments for artists in the 1920s. El Zaguan is currently one of the restored properties owned by His-toric Santa Fe Foundation, which uses it as a headquarters and as homes for its artists-in-residence program.

The name, El Zaguan, refers to the large-entry courtyards where visi-tors would dismount from their horses or carriages in the days before cars and garages. El Zaguan is a splendid example of those old entryways. Though the home is closed to the public, the foun-dation welcomes visitors to its restful xeriscape gardens featuring native, water-conserving plants Monday through Saturday.

Canyon Road is also home to two of Santa Fe's finest and most famous restaurants, The Compound and Geron-imo. El Farol is another popular and lively Canyon Road restaurant/bar that offers live music and flamenco shows, along with full menu and tapas. This mile or so of Santa Fe real estate has a lot to offer, day or night.

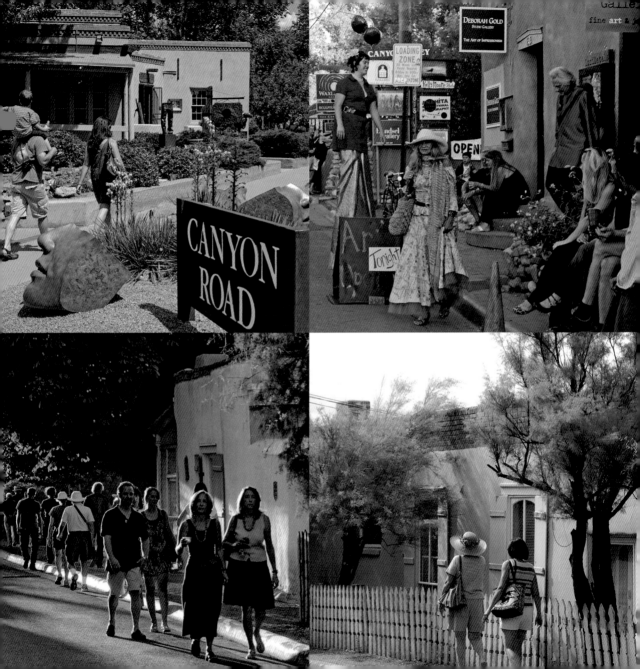

DALE BALL TRAILS

It's nearly impossible to get lost (except in thought) on the 22-mile Dale Ball Trails System that spiderwebs the foothills of east-side Santa Fe. And it's just as difficult to avoid having a good time. The variability of nature's handiwork at different elevations, the incredible views, and the well-maintained and -marked paths provide outdoor options for everyone, from the sunset stroller to the veteran mountain biker.

The system's several trailheads, all within a couple miles of the downtown area, allow locals and visitors to break away for head-clearing exercise on a whim, as easily during the week as on a weekend.

However, despite its popularity among hikers and bikers, encroaching development eventually threatened public access to what Santa Feans have long considered their own "Central Park." It took years of effort and a lot of dreaming by banker Dale Ball, but eventually, with the help of a cadre of environmentalists and local nature lovers, he was able to secure the necessary property rights and easements to allow historically popular

Hiking/Biking Trails:
www.santafe
nm.gov

Santa Fe Trails Alliance
www.trails
allianceof
santafe.org

paths to be linked with new ones, creating the present trails system. When combined with other existing trails and connecting routes, the resulting network spans 30 miles—and it's still growing! There's talk by farsighted enthusiasts of a system that would link such open spaces statewide.

Meanwhile, the Dale Ball Trails require regular maintenance and improvement, and that's where the Santa Fe Trails Alliance, formed by the city, county, and Santa Fe Conservation Trust, comes in. This organization, founded in the summer of 2009, works to recruit volunteers and to educate the public on the importance of public open spaces near or in urban areas. It's also building a social network of like-minded people who will no doubt take the trails as far as they can sustainably go.

Whether one's preference is for steep upland trails that twist through piñon forests overlooking the city, or for the broader, sage-scented pathways below, easy access to nature on the Dale Ball Trails is one reason that Santa Fe is such a great place to live, and to visit.

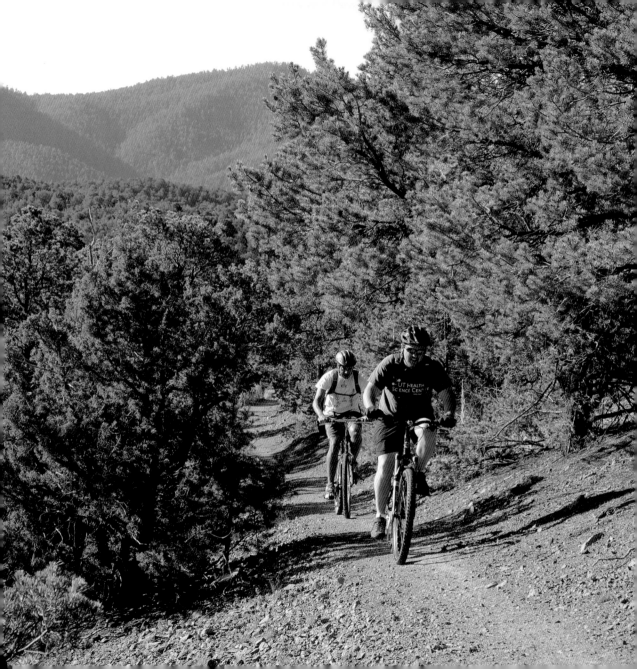

BLUE DOORS

The palette of New Mexico blues contains many shades: Guadalupe, Franciscan, turquoise, Taos, and sky among them. Whatever its manifestation, blue is the color most often chosen as a counterpoint to the ubiquitous earth tones of Santa Fe's architectural landscape.

Blue predominates on windows and doors, gates, and railings, especially in the city's oldest neighborhoods. Historic Santa Fe Foundation, a preservation nonprofit that rescues old properties, confirms that blue is the color most often found under the layers of paint scraped away in the course of restoration.

What accounts for the longevity of its popularity? The most offered reason is that blue wards off evil spirits and deflects the evil eye, which would explain its presence on points of entry. Such thinking could have arrived with Spanish settlers steeped in Middle Eastern traditions, including one that says blue deflects the power of jinns (evil spirits).

Equally compelling are the theories linking blue with reverence for the blue-robed Franciscan friars, so instrumental in the settlement of the New World; or to devotion for Our Lady of Guadalupe, who appeared in blue mantle to a Mexican Indian, Juan Diego, in 1531. And there are those who would offer the legend of the "Blue Nun," who reportedly visited Indians of the New World in what is now New Mexico and Texas in the 1600s. Was she, perhaps, the Spanish mystic, Maria de Jesus Agreda, who, in describing frequent visions and ecstasies, spoke of similar encounters, suggesting to some the miracle of bilocation?

Aside from the mystical and inexplicable, however, there are worldly reasons enough for the preeminence of blue. Who could discount the power of a New Mexico sky or of polished turquoise to inspire imitation? Whatever the reason, blue at the front door signals peace and welcome, magic enough for most.

CATHEDRAL BASILICA
OF ST. FRANCIS OF ASSISI

The Cathedral Basilica of St. Francis of Assisi is, hands down, the most iconic building in Santa Fe. Yet, clearly, it does not conform to the style of other buildings in the historic Plaza area, in size or materials. To find adobe or any of the elements of pre-Territorial construction, you must enter the church and visit the side chapel that houses the statue of La Conquistadora, Our Lady of Peace, originally brought to Santa Fe around 1625. The rest of the Cathedral reflects the changing of the guard as New Mexico became a Territory of the United States, and the leadership of the church was placed under U.S. Catholic jurisdiction.

The first evidence of that change arrived in the form of Jean Baptiste Lamy, the first bishop of Santa Fe (later elevated to archbishop), who is immortalized in Willa Cather's *Death Comes for the Archbishop*. The second was the building of a cathedral according to Lamy's vision for the seat of Catholi-

213 Cathedral Place
(505) 982-5619
www.cbsfa.org

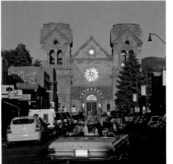

cism in a vast new region. French by birth, Lamy sent for architects from France and for stonemasons from Italy to build his church in the Romanesque style. Stained-glass windows were made in France and transported by covered wagon over the Santa Fe Trail. The scope of the project, and the money required to build it, is a testament to Lamy and his ability to reach out to the non-Catholic business community, which included Jewish merchants. It is said that the Jewish symbol etched in stone over the bronze doors honors their contributions.

Construction began in 1869 superimposed atop the existing church, which was hauled out the new front doors, adobe brick by adobe brick, when the building stopped in 1887. The adobe chapel was integrated into the new construction.

In 2005, the Cathedral was elevated to basilica status by Pope Benedict XVI, honoring the parish's importance to the spread of Catholicism.

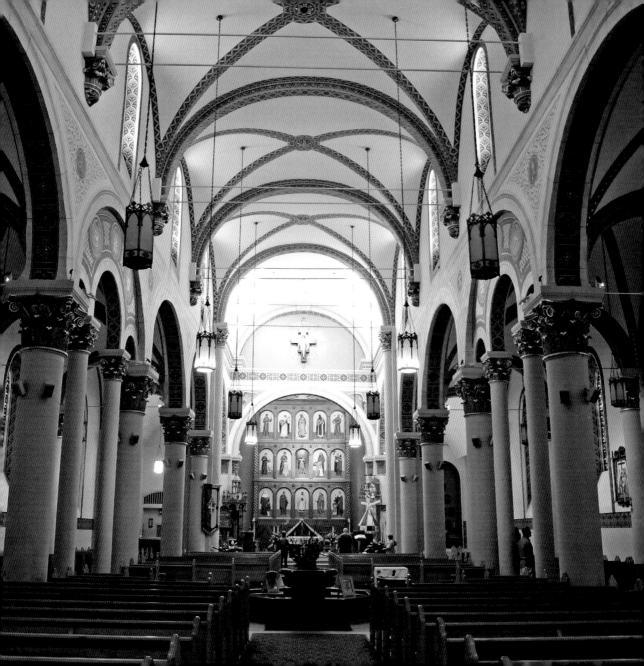

THE *SANTA FE NEW MEXICAN*

The history of the *Santa Fe New Mexican* newspaper parallels that of New Mexico, from its infancy as a U.S. Territory to the present. The press rolled into town on the heels of the U.S. military, which arrived to occupy the new territory in 1849. The newspaper began as a weekly, half in Spanish, half in English, reflecting an often-torn bicultural population. Within a year, the paper was publishing two versions, the *New Mexican* in English, and *El Nuevo Mejicano* in Spanish.

Those were the glory days of independent journalism, when newspaper owners were risk-taking visionaries; inevitably, they influenced the shape and futures of the towns they worked to build. The *New Mexican* continues to evolve as a community-based, privately owned newspaper.

That has not always been the case, however. In 1880, for example, the paper was purchased and owned for a while by the Atchison, Topeka and Santa

The Santa Fe New Mexican 202 East Marcy Street www.sfnewmexican.com

Fe Railway. In 1975, it was sold to the burgeoning Gannett chain by private owner Robert McKinney, who'd owned it since 1948. That sale, and its subsequent return to private hands, made newspaper history and speaks to the present-day character of the publication.

According to McKinney, Gannett hadn't lived up to contractual obligations to retain local management and to maintain a local perspective. Three years into the deal, McKinney took Gannett to court to get the paper back. Ten years and untold dollars later, he prevailed. McKinney's daughter, Robin Martin, assumed ownership of the paper following her father's death in 2001.

Robert McKinney's *New York Times* obit by Jennifer 8. Lee summed up the significance of that fight for local control: "What was at stake was the relationship between a community and one of its institutions. The prize in this case was no less than the oldest newspaper in the West. . . ."

THE NEW MEXICAN.

[~~VOLU~~ME I]

"*Magna est Veritas, es prevalebit*"

[NUMBER 1]

~~HARR~~IS & JONES,
~~Editors~~ and Proprietors.

SANTA FE, N. M., NOVEMBER 24, 1849.

Published at $7.00
Per Annum, in Advance.

PROSPECTUS

~~WE~~EKLY PUBLICATION, TO BE ENTITLED,
~~TH~~E NEW MEXICAN

~~Sub~~scribers propose to publish, in this
~~ci~~t weekly publication, with the above
~~to~~ be devoted to the interests of the
~~people~~ of New Mexico in general.

~~Ne~~w Mexican, in Politics and Religion,
~~main~~tain a strict neutrality, regarding
~~partisanshi~~p as utterly unnecessary and a
~~to~~ the general good of our Territory.

Harris Wm J	**H**
Henry W S	Hoxey B A
Heslep Joseph	Hickman James P
Ingles John C & H	**I J**
Iridell J B	Jones J G 2
Johnson Anthony D	Johnson James Lewis
Kemp Frederick	**K**
	King Andrew L
Lucas J S, J A & W	
Lee B F	**L**
Le Blanc P N	Lee Andrew
	Livingston Sidney S
	M

done on the authority of some letters from
Havana, written by some one subscribing
himself "The American," and who, from the
tone of his correspondence is evidently him-
self, very much excited, and anxious that a
revolution should take place whether it has
or not. These letters, however, show only
that there has been a movement of military
from Havana to Puerto Principe, and that
some militia have been ordered into service.
The writer speaks too of great excitement in
Havana, and it may be that he does not ex-
aggerate it.

From his letter of the 26th ult., we take
what follows:

have begun in Germany, in Italy, and in this
our land of Hungary!

'Thou haughty English nation! Hast thou
forgotten that thou hast decreed this prin-
ciple of non-intervention, that thou now suf-
ferest an intervention directed against con-
stitutional liberty, but thou lendest aid to
the banner of tyranny by suffering this coa-
lition of tyrants. The proud pennon of the
British mast is threatened with disgrace God
will withdraw the blessing he has lent it, if
it prove untrue to the cause to which it owes
its fame.

'Awake, oh people of Europe! On Hun-
garian grounds the battle of freedom is

FIESTA DE SANTA FE

"*A promise made* . . . and a promise kept" perfectly states the intent of Fiesta de Santa Fe, the longest-running community celebration in the United States. At its heart, Fiesta represents a promise made by Don Diego de Vargas in 1692, when he led a group of colonists back to Northern New Mexico following the Pueblo Indian Revolt of 1680, and its fulfillment by succeeding generations of Santa Feans.

In September of 1692, de Vargas knelt on a hillside overlooking Santa Fe and promised his intercessor, the Virgin Mary, that if allowed to retake the provincial capital in relative peace, the colony would hold a religious fiesta each year, and that they would rebuild an adobe church as a place of honor to contain her likeness, a statue we now call La Conquistadora, Our Lady of Peace. The statue had first appeared in Santa Fe around 1625, was rescued by settlers as they fled the revolt, and then returned twelve years later with de Vargas. It resides today inside

Santa Fe Fiesta Council
(505) 204-1598
www.santafe
fiesta.org

the Cathedral Basilica of St. Francis of Assisi.

Spanish authority was indeed restored to la Villa de Santa Fe. However, de Vargas did not live to fulfill the promise. That would be up to members of his *cuadrilla,* or supporters, and to city officials, who convened the first Santa Fe Fiesta Council in 1712, mandating an annual event "with vespers, mass, sermon and procession through the Main Plaza." Fiesta Council remains the guiding hand of Fiesta.

Over the years, the selection from among Santa Fe Hispanic families of *la reina,* or queen, to represent the Virgin Mary, and of a man to represent de Vargas, has become a central part of Fiesta. Several popular secular events—the burning of Zozobra, music, dancing, and parades—add to the community spirit of Fiesta, but it's important to recall the promise made more than 300 years ago and renewed each September in Santa Fe.

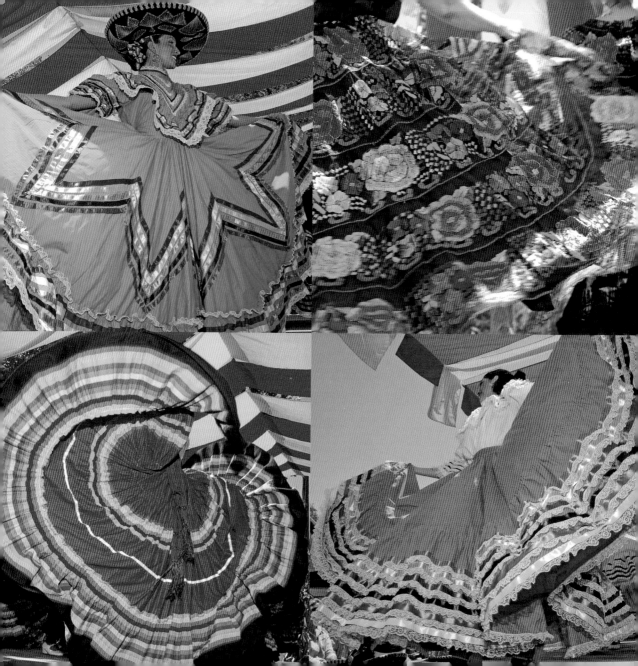

DESFILE DE LOS NIÑOS

That more than a thousand kids and their pets (in costume, yet) and hundreds of supportive adults can be made to parade in relative order through the streets of downtown Santa Fe at the height of Fiesta is a testament to the city's commitment to safe, family-centric fun.

Among the locals, Desfile de los Niños (Children's Parade), also known as the Pet Parade, is one of the most highly anticipated events of Santa Fe's event-packed year. It's been a staple of Fiesta de Santa Fe for about ninety years, so kids who march today are likely to be the grandkids of some in the crowd who did the same thing in their day. Kids who've had the pleasure of strutting their stuff alongside their best friends in front of a whole town will take home stories to tell, expand upon, and share.

Although it may look like flawless fun and frivolity from the sidelines, the parade requires much behind-the-scenes

Santa Fe Fiesta Council Parades Committee www.santafe fiesta.org

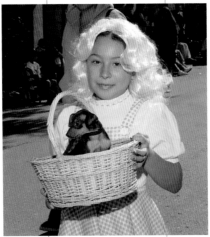

effort to make it so. This includes groups of volunteers assigned to specific tasks: refreshments, animal advocacy, registration, safety, etc. The Woof Patrol, staffed with volunteers from the Santa Fe Animal Shelter and Humane Society, "infiltrates" the parade at various intervals, looking for potential problems. The proximity of so many people and animals can be stressful, after all.

Just about any small animal—dog, cat, lizard, bird, monkey, or goldfish—can march or be carried in the parade, so the volunteers also check to make sure they're being handled properly. The scene at registration, just prior to the parade, can be crazy, and one wonders how the whole thing will come together. But once the high school marching band strikes the first notes, all creatures great and small snap to attention and the show commences. There will be prizes and popsicles at the end, along with great memories for Santa Fe families.

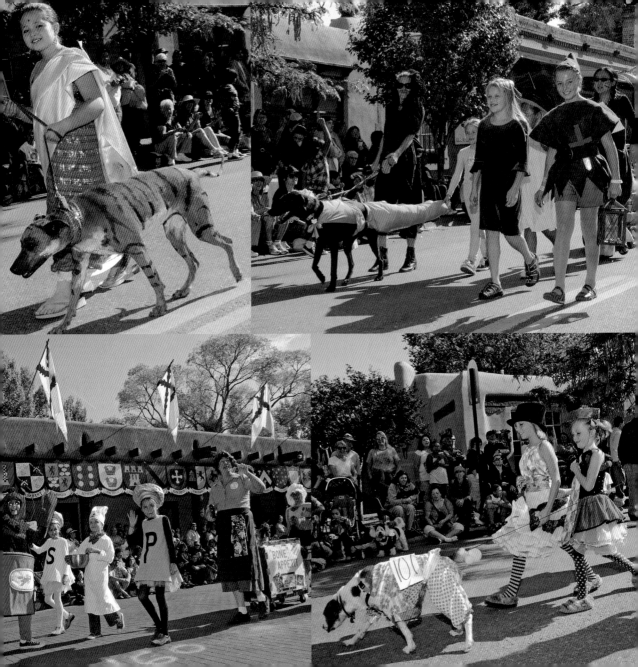

BANDELIER NATIONAL PARK

A remote canyon deep in the Jemez Mountains east of Santa Fe was once home to an ancient people, the ancestors of some of New Mexico's northern Pueblo Indians. They etched their dwellings out of volcanic tuff on the cliff walls and tended their crops beside the Frijoles River that flows clear and cool below.

Today, a 1.2-mile trail connects the ruins of this once-flourishing village, and a trail extension leads to a small kiva that's accessible by ladder. It's possible to picnic at one of the tables that line the river, to hear a ranger-led talk or tour, or to walk silently, immersed in the sheer beauty and peace of the place. And remote as it remains, the timeless canyon is only a sixty-minute scenic drive from Santa Fe. Not surprisingly, it's the most popular site in Bandelier National Park.

Outside of the canyon, Bandelier—named after nineteenth-century anthropologist, Adolph Bandelier—comprises 70 miles of trails, most of them in

Directions and Information: (505) 621-3861 www.nps.gov/band

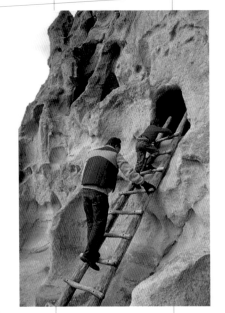

wilderness areas. During the winter months, if there is enough snow, it is possible to cross-country ski on a small network of backcountry trails accessible from NM 4, a few miles past the park entrance.

A cluster of rustic buildings built by the Civilian Conservation Corps during the Great Depression welcomes visitors at the entrance to Frijoles Canyon. Inside, a video explains the history of the area from geologic times to the present, and a bookstore offers literature on indigenous cultures and the natural world. This is where tours of the canyon meet, including a special tour offered only in the summer months on nights of the full moon, which, except for the stars visible above the narrow canyon walls, provides the only light.

There are few such easy excursions that enrich and enlighten as much as one to Bandelier National Park. This one's a memory maker.

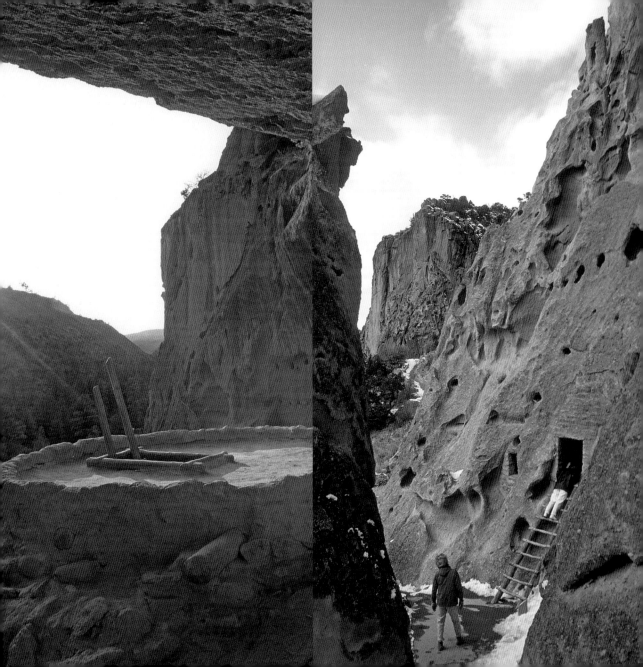

LA FONDA

There was a time when the lobby at La Fonda was the busiest and most exciting scene in Santa Fe. It was the place to meet and greet, to see and be seen. It's got a little competition nowadays, but the landmark hotel on the southeast corner of the Plaza still enjoys favored status as the city's social hub. It's said that if you hang out at La Fonda long enough, you will see everyone who has come to town lately, along with a good percentage of the local population.

(505) 982-5511
(800) 523-5002
www.lafonda
santafe.com

Old photos prove that, over the decades, guests have mingled, elbow to elbow, enjoying the gay atmosphere of La Plazuela, the indoor patio dining room, and the bar at La Fonda. Many still recall when the Santa Fe Chamber Music Festival offices were located on the mezzanine, and instrument-toting musicians routinely mingled with hotel guests. Elegant flamenco dancers used to stroll past the front desk to the old cabaret, formerly home to the Maria Benitez troupe. Movie stars, opera sing-

ers, heads of state—all have patronized La Fonda.

There have been a succession of hotels at the corner of San Francisco Street and the Plaza since Santa Fe was founded in 1610. The current incarnation was built in the 1920s, purchased by the Atchison, Topeka and Santa Fe Railroad and leased to the famous Fred Harvey, whose code of hospitality and classy "Harvey Girls" set the Western standard for customer service. The interior is Southwest Spanish Colonial style, with carved beams and corbels, hand-made furnishings, and chandeliers of tin, copper, and glass. Although recently renovated, La Plazuela retains the feeling of the original design, including preservation of the colorfully hand-painted windowpanes.

The late Sam Ballen purchased the hotel in the 1960s, and his family still runs it. Their insistence that it remain true to the 1920s vision and style secures La Fonda's place as a local treasure.

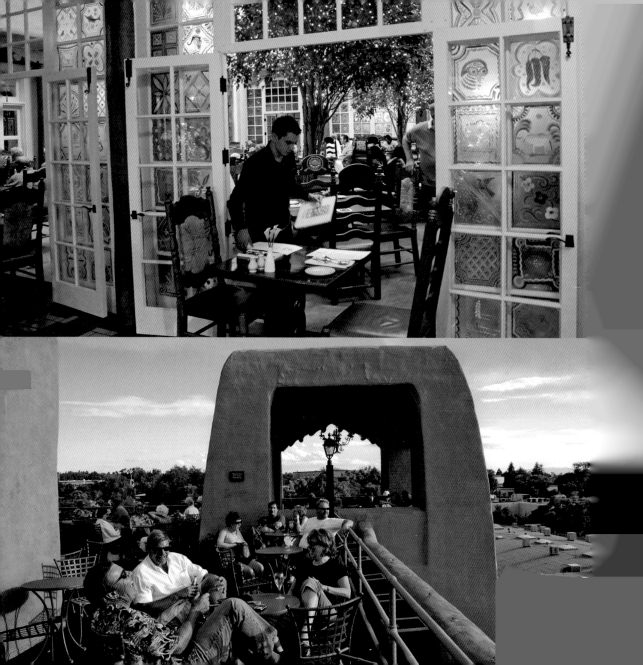

THE PIÑON TREE

Ask anyone to name the scent most reminiscent of Santa Fe, and the response is likely to be "the smoke of piñon fires." Asked what Santa Fe looks like, many artists would point to the piñon- and juniper-studded hills so often depicted in their work. And the taste of Santa Fe? "Piñon roasted coffee," perhaps, or "the buttery piñon nuts sold along the roadside following a harvest— roasted, salted, ready to crack and savor."

The piñon tree offers much more than sensual delights, however. The rangy, gnarl-limbed piñon of the intermountain West has, for millennia, provided sustenance, fuel, and shelter to the people of this semi-arid landscape. So important was the piñon to the First Americans that treaties between the U.S. and Western tribes often designate ownership rights to the crop. Rituals celebrating this most giving of trees survive in the folklore and traditions of the region.

Piñon Products:
www.madein
newmexico.com

Piñon Facts:
www.pinonnuts
.com

Many Northern New Mexico families still trek to the nearby piñon forests in harvest years, as their ancestors did before them. While no longer on foot or horseback, these latter-day gatherers arrive by trusty old truck and car, with baskets, ladders, blankets, and "shaking sticks" in hand. Soon, excited shouts of "Over here, Papa!" and "Look, that tree is better!" fill the chilly fall air, joined by the raucous chorus of scolding piñon jays, worrying over their food supply.

The trick is to separate the ripe, opening cones from the trees, coaxing them skillfully to rest on outspread blankets. Later, there will be the work of cleaning and roasting the nuts and preparing old family recipes.

Demand is high for the New Mexico piñon, the best-tasting of the varieties of pine nuts. But as "gourmet" as they've become, buying them in plastic sandwich bags from the guy parked on the side of the road remains a favorite Santa Fe tradition.

THE HIGH ROAD TO TAOS

The "High Road" snakes along the spine of the Sangre de Cristo Mountains, connecting traditional villages between Chimayo and Taos. Beyond its spectacular views, this 40-mile route is the best way to experience the *norteño* lifestyle that inspires much of the artwork found in Santa Fe galleries and markets. For two weekends in September, High Road artisans welcome visitors to their annual studio tour. It's the perfect time to explore the back roads that emanate from the High Road, just as autumn leaves turn the mountains to gold.

Chimayo, about 19 miles north of Santa Fe, is best known for its tiny church, the Santuario de Chimayo, and for the healing miracles attributed to the sacred dirt upon which it stands. El Rancho de Chimayo, a restaurant serving typical New Mexican dishes in a rambling old family home, is a must-stop, as are the shops of the Chimayo weavers, masters of the distinc-

High Road Artisans Directory: www.highroad newmexico.com

tive Rio Grande–style rugs and other woolen items.

Cordova is the center of the Spanish Colonial–style woodcarving community, and several of its best-known artisans open their studios to the public. An outdoor gallery of huge wind chimes welcomes visitors to **Truchas,** a photogenic village perched precariously on a cliff. Its main street boasts many fine contemporary galleries owned by the artists who live there.

Pastoral **Las Trampas** sits in a top-of-the-world valley dominated by a historic adobe church. Observant visitors will spot the roadside *canoa,* a long span of hollowed-out logs carrying irrigation water above a small canyon, a remnant of the old farming methods.

Peñasco is the only "town" on the High Road and the place to purchase picnic supplies for an unanticipated side trip to spectacular Santa Barbara Canyon. Peñasco is also the home of Sugar Nymphs Bistro, a regional favorite.

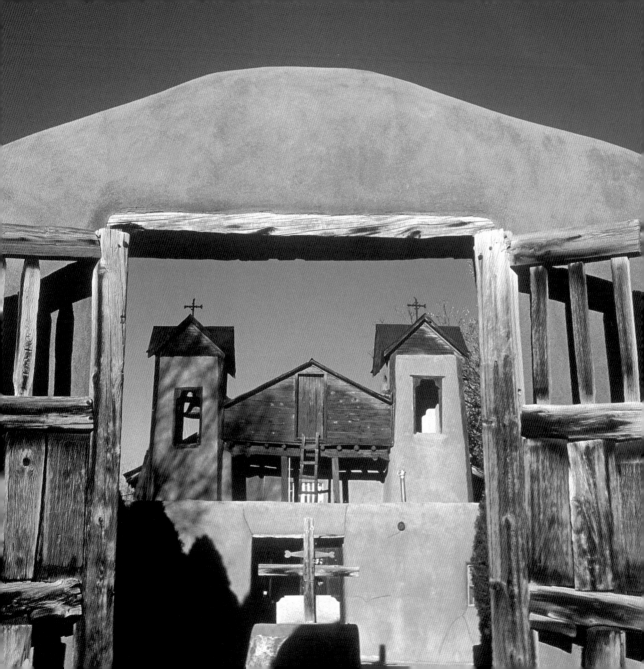

SHIDONI FOUNDRY AND GALLERIES

Shidoni is the Navajo word for "lovely place in an old apple orchard that's become a crossroads for artists, collectors, expert pourers of bronze, local families and tourists." Not really. *Shidoni* is a Navajo greeting to a friend.

And "greeted as a friend' is exactly how people feel when they reach Shidoni Foundry and Galleries and discover that the whimsical sculpture park inhabited by huge bronze creatures is theirs to wander. The public is encouraged to visit the eight-acre campus, comprised of the park, two indoor galleries, and the famous 14,000-square-foot foundry, where craftsmen pour 2,000-degree molten metal—about 9,000 pounds of it a month—into ceramic forms for some of the world's best sculptors.

Shidoni represents the work of about a hundred artists and rotates its exhibitions so the experience is always fresh. The indoor galleries house smaller bronzes and many other types of art.

1508 Bishop's Lodge Road (505) 988-8801 www.shidoni.com

There are always knowledgeable people about to answer questions, including at the Saturday afternoon pouring sessions.

Many artists stay at Shidoni for extended periods of time to create works in cast bronze or aluminum and to collaborate with the owners and the staff, most of whom are working artists themselves. Allan Houser, Jim Amaral, Dan Namingha, Michael Naranjo, Jesús Bautista Moroles, and Doug Coffin are just some of the sculptors whose patronage helped Shidoni establish an international reputation.

Shidoni is located about 5 miles north of the Plaza on Bishop's Lodge Road in the village of Tesuque, an enchanting drive. The sculpture garden is open year-round during daylight hours, but call ahead for pouring schedules and for indoor gallery hours. Shidoni is the longest-lived gallery in Santa Fe, a favorite summer field trip and picnic spot for families, and an educational opportunity any time of year.

EL RANCHO DE LAS GOLONDRINAS

Miguel Vega y Coca founded the "The Ranch of the Swallows" in the riverine bosque south of Santa Fe in 1710. Its distance from Santa Fe (about a day's journey by wagon) and its location on the Camino Real, the royal road from Mexico City, made it a natural stopover, or *paraje,* for travelers, and it served in that capacity also.

Today, Rancho de Las Golondrinas is reborn as a living museum of eighteenth-century Spanish Colonial settlement. Like all ranches of the era, Las Golondrinas is a self-sustaining village set up to meet the basic needs of the residents' lives, from production of food and raw materials to its processing for the intended use. Sheep raised on the ranch provide the wool that is spun and woven into clothing, blankets, and rugs. A mill grinds wheat into flour, which is made into bread in the courtyard *hornos* (round adobe ovens).

A walk along the rancho's dirt paths opens to fields of vegetables and grains, connecting the blacksmith and wheelwright shops to the mill, the storehouse for dried herbs, the chapel, a defensive tower (*torreon*), and other structures. Guides dressed in period clothing engage in daily chores while educating visitors.

Life in the colonial era was as sweet as it was difficult. Scenes at the ranch are often moving and sure to leave an indelible impression, like the shepherd's hearth in one of the restored kitchens, where sick animals were allowed to sleep overnight, enveloped in warmth.

Many popular events take place at Las Golondrinas, along with the rancho's own spring and harvest festivals. Though the events bring nonstop period entertainment and food booths to a plaza near the entrance, self-guided walking tours of the grounds allow visitors to savor at their own pace another world and time.

Las Golondrinas
334 Los Pinos
Road
(505) 471-2261
www.golondrinas
.org

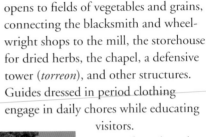
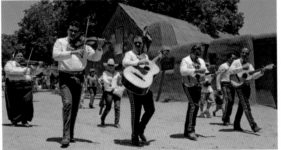

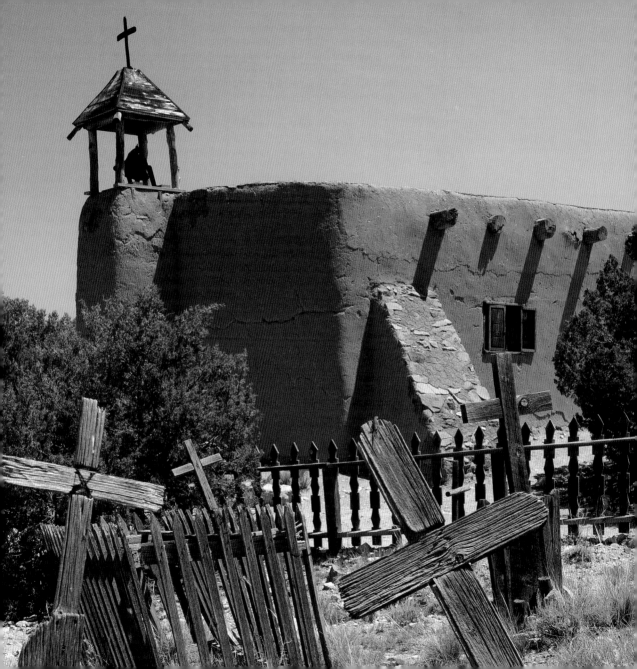

ROADHOUSES

Roadhouses are friendly eateries that city folks "discover" in the villages and along country roads close enough to their towns to allow a weeknight stop or leisurely weekend breakfast. Most are old houses or stores that have been turned into diners or cafes. Good company, honest food, and fair prices are guaranteed.

Harry's Roadhouse and Bobcat Bite are country neighbors on Old Las Vegas Highway, about ten and fifteen minutes southeast of Santa Fe, respectively, on a remnant of old Route 66. The parking lot at Harry's is always full, but the wait's not long. The home-turned-diner boasts three ample dining rooms, a big bar with its own tables, plus counter service. The menu features American diner classics and New Mexican dishes. The outdoor patio in the back is the most popular spot in warm months, with its bright umbrellas and stands of shoulder-high flowers.

Bobcat Bite is a cozy place with a big reputation for burgers, steaks, and chops. There may be a wait for one of the twenty-five or so seats, but a picture

Harry's Roadhouse
96B Old Las Vegas Highway
(505) 989-4629

Bobcat Bite
Old Las Vegas Highway
(505) 983-5319

Tesuque Village Market
138 Tesuque Village Road
(505) 988-8848

Mine Shaft Tavern
2846 State Highway 14 N
(505) 473-0743

window with a view of the hills out back and a busy bird feeder provides a diversion. The Bite was once a trading post and then a gun shop before becoming a roadside eatery in 1953. Previous owners fed the local bobcats (hence, the name). The Bite offers great ten-ounce green chile cheeseburgers.

Heading north this time out of Santa Fe on Bishop's Lodge Road, a narrow country lane wends its way through Tesuque, to Tesuque Village Market. There's a long covered porch with a wood-burning pizza oven, and inside, a cozy bar, dining room, deli, and wine section. The menu is extensive, and breakfasts are huge.

The Mine Shaft Tavern is on the main street in Madrid, a scenic, forty-five-minute drive south on NM 14. Built in the 1940s by the coal-mining company that pretty much owned the town, it hasn't changed much: same furniture, wide-planked wood floors, and long lodgepole pine bar. The new management's appreciation for natural foods and fresh salads shines through among typical pub offerings.

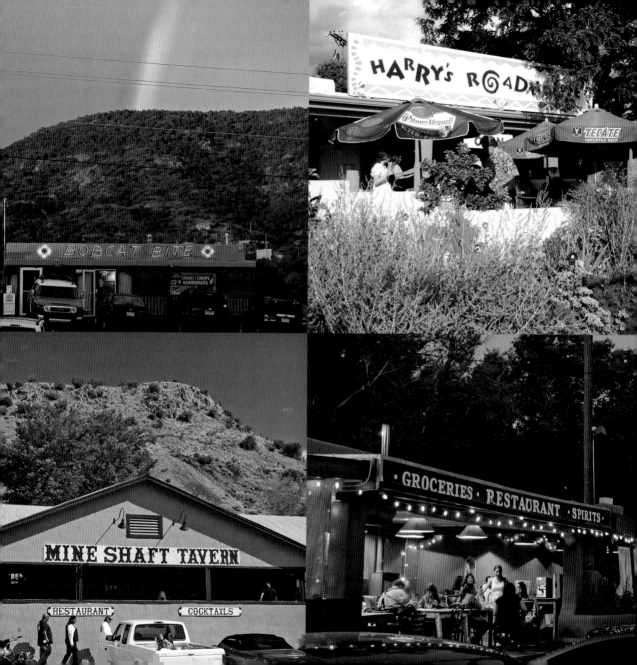

CROSS OF THE MARTYRS

The towering Cross of the Martyrs on the hillside overlooking Santa Fe northeast of the Plaza is actually the newer of two monuments dedicated to the twenty-one Franciscan friars killed in the Pueblo Indian Revolt of 1680. The first, dedicated in 1919, is currently surrounded by a development on private land and maintained by the Historic Santa Fe Foundation.

The "new" Cross of the Martyrs site was dedicated in 1977, and includes a commemorative walkway marked at intervals with plaques that provide a historical timeline of the city. The walkway is paved, and there are handrails, but it's steep, and intermittent stairs present an obstacle to people in wheelchairs. For the willing and able, it's worth the trek just to take in the expansive city views, especially at sunset when the sky's on fire and the city lights begin to twinkle. What you'll see behind the cross is just as impressive— an unrestricted view of the nearby Sangre de Cristo mountaintops.

Cross of the
Martyrs
Top of hill
between Otero
Street and
Hillside Avenue
Access from
Paseo de Peralta

Old Cross
Top of hill on
Paseo de la Loma
No public access

The commemorative walkway begins at a well-marked stairway on Paseo de Peralta, between Otero Street and Hillside Avenue. There is no parking on Paseo de Peralta, but the stairway is just a few blocks northeast of the Plaza, and parking spots can be found on the side streets. It is also possible to access the Cross of the Martyrs by driving to the park at the top of the hill behind the cross (by way of Otero Street), where the foundations of the original Fort Marcy lie exposed to the elements.

Interestingly, one of the best views of the Cross of the Martyrs is from the bottom of the hill, on the closing night of Fiesta de Santa Fe each September. The Fiesta officially closes with a candlelight procession from the Cathedral Basilica of St. Francis of Assisi to the monument, when the hillside glows in a spiral of light as Santa Feans by the thousands ascend in a celebration of thanksgiving and community spirit.

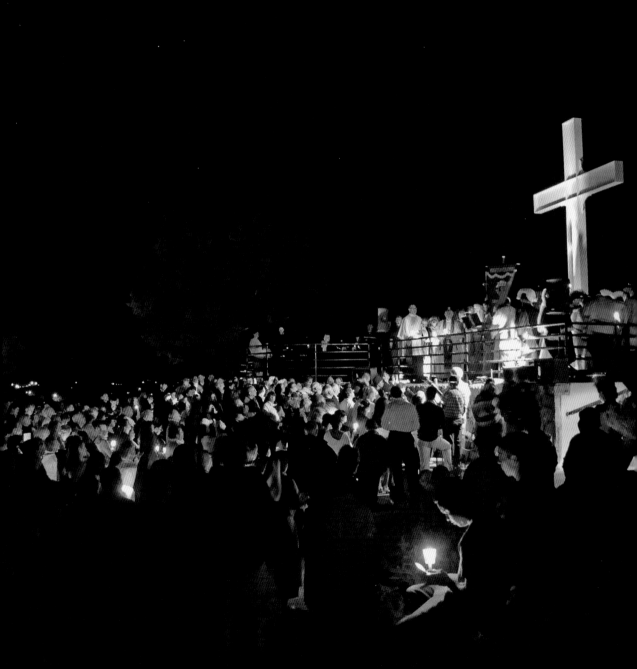

COWBOY CULTURE

You could say Santa Fe (and its environs) is responsible for keeping the Old West alive, and you'd be right. Northern New Mexico has helped shape the world's idea of what Western America looks and "feels" like, thanks to Hollywood and her decades-long relationship with the city.

So many of the landmark and most popular cowboy movies were shot here—*All the Pretty Horses, Silverado, Wyatt Earp, The Cowboys, City Slickers,* and even spaghetti Westerns like *My Name Is Nobody*—that the mountains, prairies, arroyos, and dramatic skyscapes of this high-desert plain are imprinted on the minds of moviegoers as quintessentially Western.

Santa Fe is one of the few places that can offer the raw material needed by filmmakers, along with the city amenities required to house and feed cast and crew and supply and support production. Three permanent Western-town sets and one Spanish Colonial ranch (now a living museum), at which

scenes from hundreds of Westerns have been shot, are tucked into the buttes and foothills of Santa Fe. Garson Studios at the College of Santa Fe provides first-rate soundstages for interior shots. The city teems with production people, and boasts a pool of eager "extras" just waiting for that casting call.

And what about cows and horses, wranglers, broncobusters, and trainers? Just a phone call away. When the cast of *City Slickers* encountered snake problems while filming in the arroyos near Abiquiu, the resident snake lady was called. Once she'd walked the area and rounded them up with a long pole, filming resumed. When a New York actress playing a rodeo queen in another movie admitted she couldn't ride a horse, a double was easy to find.

There are real-life cowboy scenes too, of course, in the wide-open prairies and lush mountain pastures of Northern New Mexico—enough for the city to stake a claim on this proud Western heritage.

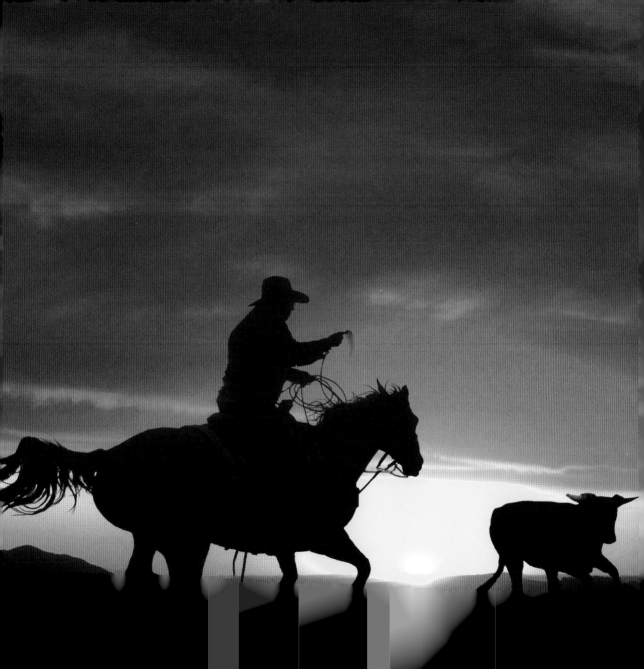

SCHOOL FOR ADVANCED RESEARCH

By the turn of the twentieth century, stunning discoveries in the ancient world—in Egypt's Valley of the Kings, at Ephesus and Troy—had ignited the world's imagination. The fever for exploration was high, as was interest in the emerging disciplines of archaeology, anthropology, and related fields of human study.

Here in Santa Fe, a diverse group of scholars led by passionate amateur (later professional) archaeologist Edgar Lee Hewitt and pioneering anthropologist Alice Cunningham Fletcher, focused on the ancient cultures of the American Southwest. Their efforts led to the founding about a hundred years ago of what is now the School for Advanced Research (then called the School of American Archaeology) and its off-shoot, the Museum of New Mexico. The value of these now-separate institutions in the preservation, documentation, and appreciation of human progress on this land cannot

School for Advanced Research
660 Garcia Street
(505) 954-7200
www.sarweb.org

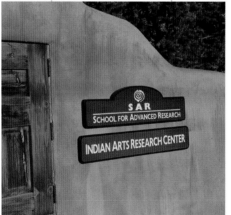

be overstated. Through its Advanced Seminar and Resident Scholar programs, Indian Arts Research Center, and an outstanding press that publishes the work of visiting scholars, SAR remains a point of convergence and interaction for researchers from diverse fields who travel here to reflect upon and advance our knowledge of human emergence.

Much of the work that goes on at SAR's picturesque east-side campus is accessible to the public through an aggressive outreach program of lectures, publications, and special events. A significant Native art/artifact collection from the Indian Art Fund, the precursor of the Santa Fe Indian Market, may be viewed on specified days.

Many people desire a richer experience and deeper understanding of the cultures shaped by this place and whose influences linger in the character of Santa Fe. Such seekers are well served by institutions like the School for Advanced Research.

SKI SANTA FE

The Sangre de Cristo Mountains loom large above Santa Fe. An upward glance is sometimes all that's needed to monitor snowfall at the summit from just about anywhere in the city. And because it takes under an hour to drive the 16 miles to Ski Santa Fe, visual affirmation of fresh powder may be all it takes to tip the balance between work or play on a given winter's day.

Visit www.ski santafe.com

Snow Report: (505) 983-9155

Santa Fe snows are dependable, and powder is the exception rather than the rule in this dry climate. The sun is brilliant and surprisingly warm, once the fast-moving snowstorms blow through. The top-of-the-world scenery from any one of the seventy-two ski runs at the ski basin is breathtaking. What reason would anyone have not to ski or snowboard at this most accessible winter playground?

The Ski Santa Fe experience differs from that found on other mountains; there's no adjoining "village" for one thing, although there are eating, shop-

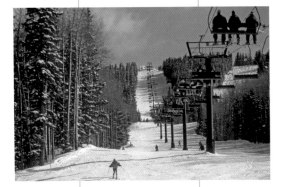

ping, and rental options up top. Santa Fe, with all its amenities, is the official skiers' headquarters.

Ski Santa Fe boasts 1,725 vertical feet of skiing on 660 acres of varied terrain, from chutes to bumps and bunny slopes to bowls. Seven lifts move more than 9,000 skiers per hour, so lift lines are seldom long. The New Millennium Triple Chair transports skiers to 12,075 feet, one of the highest elevations at a U.S. ski area. A snowsport school offers lessons in snowboarding and downhill, telemark and cross-country skiing, and a children's center provides safe fun for kids.

Once the snow disappears, the basin beckons with alpine hiking and biking trails. In the fall, a scenic chairlift whisks "leafers" far above the timberline for a bird's-eye view of the golden aspen foliage. How many other cities are able to claim such a four-season park in their own backyards?

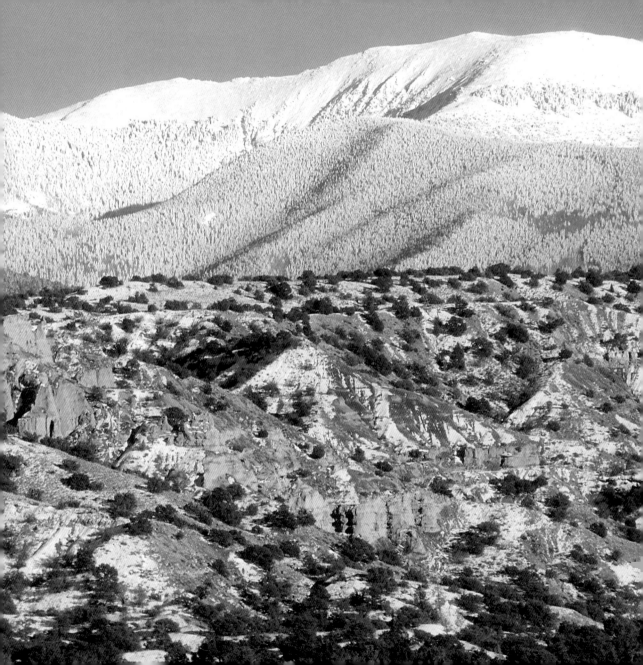

ST. FRANCIS AUDITORIUM

Change came quickly to Santa Fe once New Mexico achieved statehood in 1912. The sudden influx of newcomers with East Coast preferences and tastes threatened to tip the balance between history and modernity forever. In history's defense, a group of influential artists, architects, social scientists, and businessmen set out to define and preserve "Santa Fe Style" for future generations.

Artist Carlos Vierra wrote at the time, "There is a reason [to do so] in our rare climate, in our wonderful surroundings and in what is left of historic Santa Fe. Are we going to destroy what is left, or are we going to build in keeping with it?"

Led by architect John Gaw Meem, the group promoted an "old-new" building style based on design elements of the Spanish-Pueblo missions, but which took advantage of modern materials and building practices. Built in 1917, the New Mexico Museum of Art on the northwest corner of the Plaza and its lovely chapel-like St. Francis Auditorium exemplify

New Mexico
Museum of Art
107 West
Palace Avenue
(505) 476-5072
www.nmart
museum.org

the best of that "Pueblo Revival" style.

The interior of St. Francis Auditorium exhibits many elements found in pueblo mission churches, such as at Acoma and Pecos: massive structure, soaring heights, a projected balcony (choir loft) at the rear, rough-finish plaster, and ceiling ornamentation consisting of *latillas* (thin stakes) that rest upon *vigas* (roughly hewn heavy beams), and supported by double corbels. A stage replaces the altar and long rows of wooden pews serve as seating in this lovely performance venue.

Oil murals added in the Works Progress Administration era grace the auditorium and provide a focus for contemplation of the auditorium's namesake. Three murals depict events in the life of St. Francis: a triptych above the stage titled *Apotheosis of St. Francis;* the conversion of St. Francis; and the conversion of St. Clare, a faithful disciple.

One of Santa Fe's most revered public spaces, St. Francis Auditorium honors the efforts of the city's first historic preservationists.

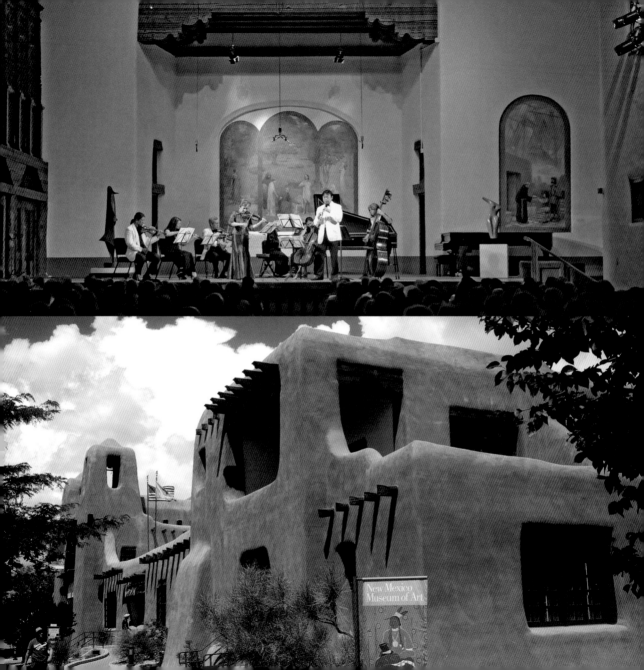

CHAMISA

There's no mistaking chamisa for another plant once you've seen it in the fall along the roadside. Growing to heights of 5 feet, and just as wide, it would be difficult to forget the huge puffs of autumnal color. Often, the flowering golden orbs bloom in tandem and proximity to purple aster, bringing out the *plein air* artist in everyone.

Chamisa Seeds:
contact@plantsof
thesouthwest.com

Chamisa is highly prized by other sorts of artists, too—those who crush the pungent yellow flowers to make dyes for yarns, and, long ago, to impart color to buckskin shirts and leggings. Following long-established tradition, contemporary *santeros* (makers of religious art found at Spanish Market) rely on chamisa to produce the natural-pigment yellows required for their work.

Healing artists of the Pueblo and Hispanic *curanderos* find medicinal uses for chamisa, used in teas, gargles, and ointments.

In the springtime, chamisa is among the first plants to push through the thawing earth, providing early forage for deer. Because it's also called rabbitbrush, it's possible that the plentiful population of desert jackrabbits also crave the narrow, silver-blue leaves. Chamisa sends its roots deep into sandy arroyos, the natural drainages that web across the desert floor. Tenacious and drought-tolerant, chamisa is an increasingly popular pick for xeriscape gardens.

Visitors to City Hall in downtown Santa Fe are often stopped in their tracks by the super-pungent smell of the chamisa in full flower beside the statue of St. Francis of Assisi. They ask "What is that smell?" just before a big sneeze reveals, "It's chamisa," the supposed bane of allergy sufferers. Yet allergists tell us the plant is an "indicator" of other allergens in the area, and not the culprit at all. So go ahead and cut some of the showy branches for floral arrangements, or plant a bush in the garden as a celebration of fall in Santa Fe.

MUSEUM HILL

If Santa Fe has a museum "district," then Museum Hill, located on the knoll that dominates Camino Lejo just off of Santa Fe Trail, is it. Four world-class museums, each serving a distinct cultural mission, and the state's anthropology laboratory comprise the compound and border expansive Milner Plaza, site of the annual International Folk Art Market. Its relative isolation from the well-worn gallery and museum paths of downtown Santa Fe encourages a leisurely pace and thoughtful consideration of the exhibitions.

The Museum of Spanish Colonial Art was founded to preserve and promote Southwest Spanish Colonial arts produced in New Mexico and southern Colorado. Now more than seventy-five years into its mission, and through the acquisition of its beautiful permanent home and storage facility at Museum Hill, the museum has extended its reach to include non-regional Spanish Colonial art.

The Museum of Indian Arts and Culture and the adjacent anthropology

Museum of Spanish Colonial Art
750 Camino Lejo
(505) 982-2226

MIAC and Anthropology Lab
708–710 Camino Lejo
(505) 476-1250

Museum of International Folk Art
706 Camino Lejo
(505) 476-1200

Wheelwright Museum of the American Indian
704 Camino Lejo
(800) 607-4636

lab form the state's research and exhibition center for Native American arts of the Southwest. Charged with preserving, conserving, and curating New Mexico's extensive Indian artifact collection, the MIAC stewards more than 75,000 exhibition-quality artifacts.

The Museum of International Folk Art, part of the state museum system, houses the world's largest collection of folk art. The Girard Wing showcases an immense collection of folk art from one hundred countries donated by Alexander Girard, who also designed the delightful exhibition in the manner of cultural vignettes in miniature.

The Wheelwright Museum of the American Indian hosts changing exhibitions of contemporary and traditional Native American art of the Southwest. There's an emphasis on collecting the work of living Native artists.

Special events and educational programs take place on a regular basis at each of the museums. The gift shops are must-stops.

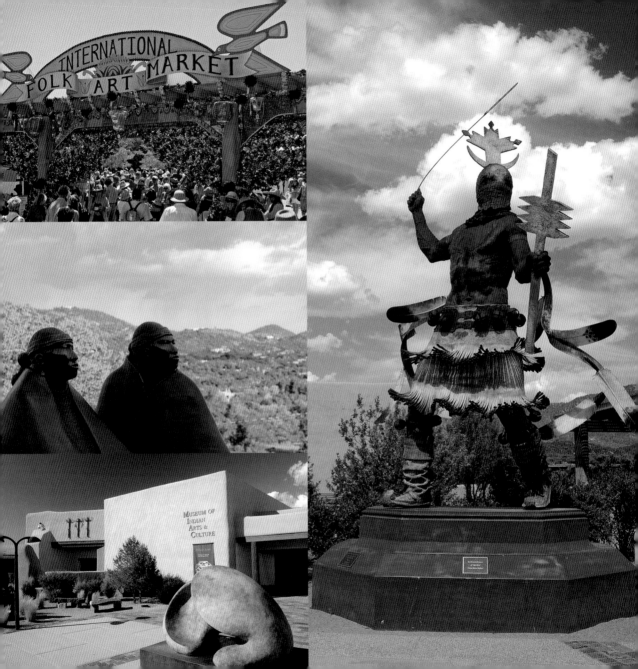

PICKUP TRUCKS

Forget Bentleys and Lamborghinis. Santa Fe's status symbol boasts mud flaps, winches, and tires so high they won't bog down in the muck of melting snow. With far more unpaved roads than paved ones in huge Santa Fe County, a sturdy truck trumps a luxury car any day.

Restored vintage trucks from the '30s, '40s, and '50s are the ultimate status symbols. Leftovers of the old farms and ranches and abandoned for decades, they're reborn as attention-getting road dandies. They're available for restoration because New Mexico's arid climate helps preserve the old trucks found propped up on blocks or strangled in weeds. Scouts scour our back roads for "deals" they can buy cheap and sell for big money elsewhere.

"There's a romance about them," says fine-art photographer Barbara Bowles, whose work captures the nostalgia and beauty of abandoned trucks. "To someone living in a big city, they stir longings for a slower time and wide open spaces." But many Northern New

Mexico families aren't disposed to selling their old vehicles, representing, as they do, a connection to family members, some long gone. "Whenever I spot a truck I want to photograph, I ask permission and am usually privileged to hear a story associating it with an older family member. One old gentleman started to cry as he retold a story about his father and the truck," she recalled.

Next in the hierarchy of trucks are those that work for a living: paint-spattered, dinged, and rough-ridden after a season of firewood or construction hauling. These identify the owner as self-sufficient and hardworking—desirable qualities in the West.

New pickup trucks, shiny and smelling of fine leather, have their place, too. These are "dress vehicles," the stars of Santa Fe Opera tailgate parties, where they graciously accommodate table, seating, and all the fixings for a great outdoor event. There's no place that a truck isn't welcome in Santa Fe, and there's a truck for every occasion.

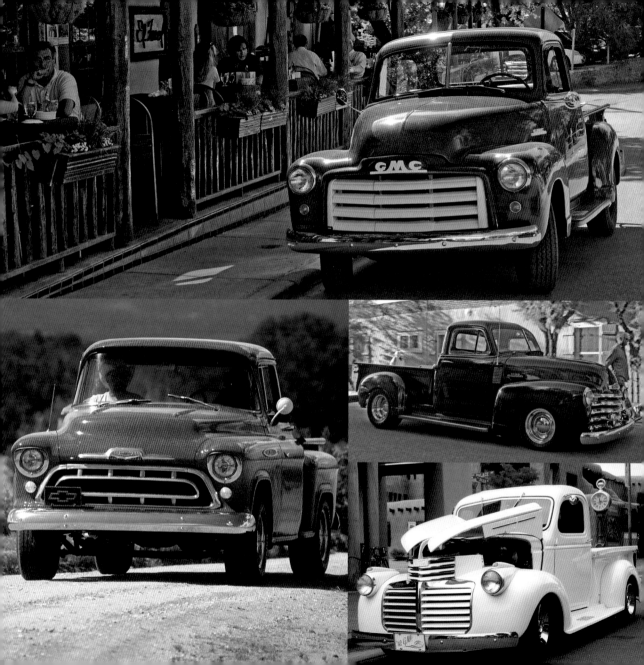

THE LIGHT

Artists and filmmakers are seriously taken with the quality of light in Santa Fe, describing it as crystalline and sparkling, and they tout its ability to reveal artistic truths, even in shadows, that are hidden elsewhere. Desire to capture this light is why many of them travel here, and why many stay.

Peter Lipscomb is a writer and lover of Santa Fe light, especially as it relates to astronomy and the night sky. He has partnered with New Mexico State Parks in support of their award-winning "Reach for the Stars" program, and served as director of the Night Sky Program of the New Mexico Heritage Preservation Alliance. People like Peter work with one another and with government officials to reduce light waste through passage of outdoor lighting ordinances. Thanks to such efforts, New Mexico has a Night Sky Protection Act that's having an impact. Though it's perhaps an unromantic approach to such an enchanting subject, "fighting for the light"

Reach for the Stars New Mexico State Parks (505) 476-3355 nmparks@state .nm.us

Peter Lipscomb nightsky@eyes fullofstars.com

is Santa Fe's way of recognizing and preserving a fragile, endangered resource.

In unscientific language, Lipscomb explains that at an altitude of 7,200 feet, Santa Fe has a third less atmosphere than is present at sea level. So, the air is simply thinner here, and more transparent. The air's very dry here, too, so there's less distortion than in humid regions.

As a result, Santa Fe's sky is azure, the clouds deeper, darker, or brighter, depending on weather conditions, and the clouds' traverse of the heavens is much more dramatic. At night in calm weather, that transparency makes the background darkness of the sky closer to true black, supporting an enhanced level of contrast. The moon, stars, and planets appear as starkly brilliant celestial objects.

Lastly, New Mexico's smaller population means that we haven't yet completely blotted out the stars with the perpetual twilight common to large cities. For the time being, at least, this perfect light prevails.

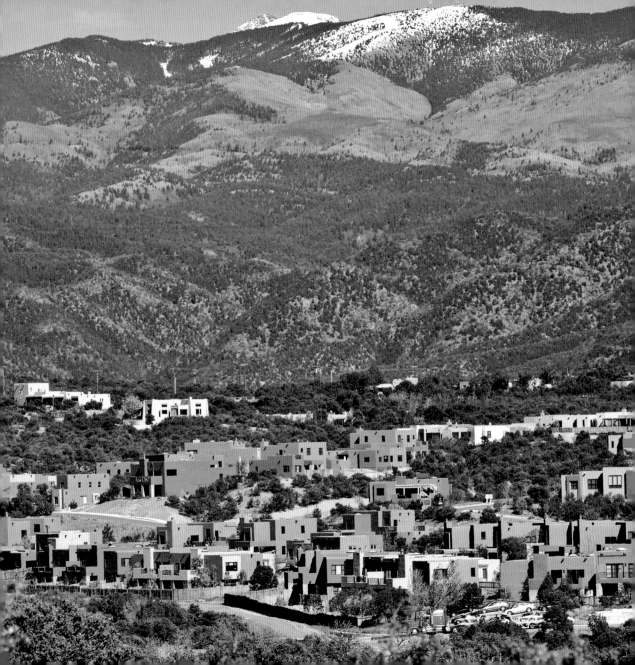